PAINTING THE
Drama *of* Wildlife Step by Step

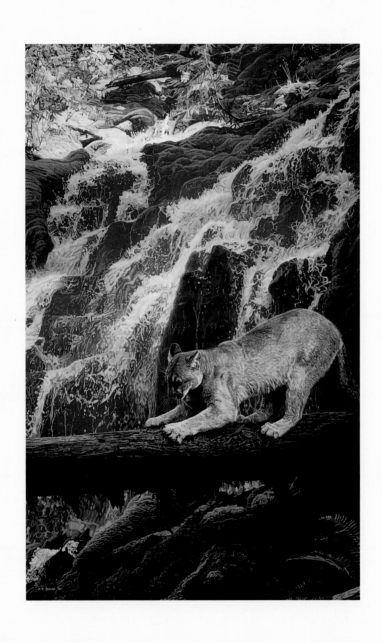

PAINTING THE
Drama *of* Wildlife
Step by Step

Terry Isaac

NORTH LIGHT BOOKS
CINCINNATI, OHIO

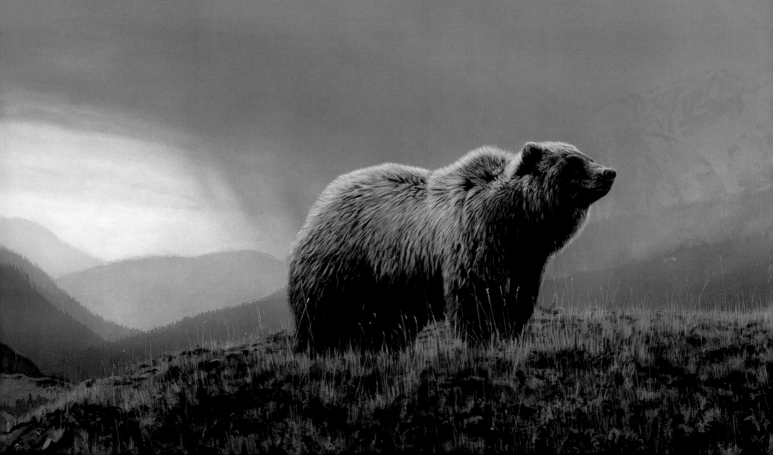

A C K N O W L E D G M E N T S

I must thank my wife, Connie. Also trained in art education, she not only helped with painting concepts, but all the way through the process to completion. She also did the word processing and first editing of the manuscript for this book. Without her help my art would not be where it is today.

I would like to thank my mother-in-law, Sharon Toland, not only for her editing, but for her insights into the connections between the art of nature and literature.

I must acknowledge my publisher, Mill Pond Press; Robert Bateman, who has had a huge impact on my art and career; my family and friends; and my high school art teacher Reita E'Laine, who not only taught me how to be an artist but also gave me her place in a Robert Bateman workshop in 1987 in Montana, thereby starting me on my way. I thank all past and present artists—art is not created in a vacuum and I have been influenced and taught by all styles and movements.

A thank-you must also be given to the editors and staff at North Light Books who have so capably put together my words and paintings—Pam Seyring, Jennifer Long, and particularly Rachel Wolf, who helped orchestrate the concept for this book and outlined and organized my ideas.

I dedicate this book to my daughter, Emily, a work-in-progress and the best art my wife and I have ever created.

Library of Congress Cataloging-in-Publication Data

Issac, Terry
 Painting the drama of wildlife step by step / by Terry Isaac.—1st ed.
 p. cm.
 Includes index.
 ISBN 0-89134-812-3 (hardcover: alk. paper)
 1. Wildlife painting—Technique. I. Title.
ND1380.I82 1998
758'.3—dc21 97-49068
 CIP

Edited by Rachel Rubin Wolf and Jennifer Long
Production edited by Marilyn Daiker
Designed by Brian Roeth
Cover art: *The Sharpening Place* by Terry Isaac, 30″ × 18⅞″ (76.2cm × 47.9cm)
Title page art: *Storm Watch—Grizzly Bear*, 24″ × 36″ (61cm × 91.4cm)

Terry Isaac lives with wife, Connie, and daughter, Emily, in the Willamette Valley of Oregon. He paints North American wildlife and landscape and has recently added the animals and birds of Africa and Asia to his repertoire. Although Isaac received a formal art education, he believes his best training has come from fieldwork and from studying the work of favorite wildlife artists such as Robert Bateman.

Painting in acrylics, Isaac strives to capture unique characteristics of wildlife and habitat. Depiction of light is an important element in his work. He is inspired by large panoramas as well as close-up views, and by subjects ranging from whales to hummingbirds.

Isaac has been selected to participate in several important art exhibitions, including the Leigh Yawkey Woodson Art Museum's prestigious annual *Birds in Art* since 1987 and *Wildlife: The Artist's View* in 1990 and 1993. His work is also included in their permanent collection. His work was chosen for *Wildlife Art in America*, an exhibition at the James Ford Bell Museum of Natural History in Minneapolis in 1994. Isaac has served as featured artist at several major exhibitions including the Friends of the National Zoo Arts Festival at the National Zoological Park in Washington, DC, and the Florida Wildlife Exposition in Orlando, Florida.

In the spring of 1996, Isaac was hired by Walt Disney Productions as a visual consultant, painting a main character for an upcoming feature-length film. Additional creative endeavors include commissions to paint the 1991 New York duck stamp and to create fourteen waterfowl drawings for the *Audubon Bird Handbooks* (McGraw-Hill), published in 1987. His paintings are included in several recent books, *Painting Birds Step by Step* by Bart Rulon (North Light Books, 1996), *More Wildlife Painting: Techniques of Modern Masters* by Susan Rayfield (Watson-Guptill Publications, 1996) and *The Best of Wildlife Art* edited by Rachel Rubin Wolf (North Light Books, 1997).

Isaac taught middle school art for eight years before turning to art full time. He now teaches painting workshops for adults. His paintings have been published by Mill Pond Press of Venice, Florida, since 1988.

PHOTO BY NORMAN R. LIGHTFOOT

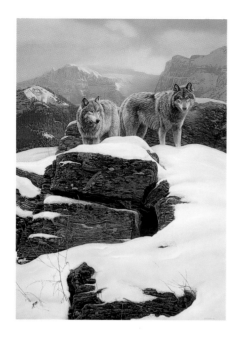

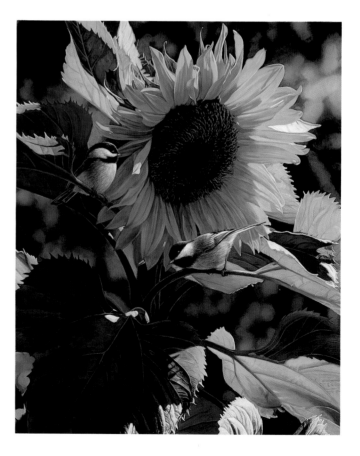

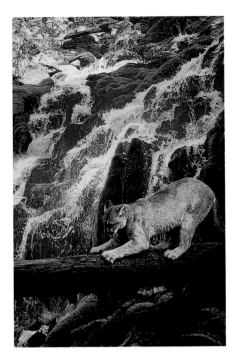

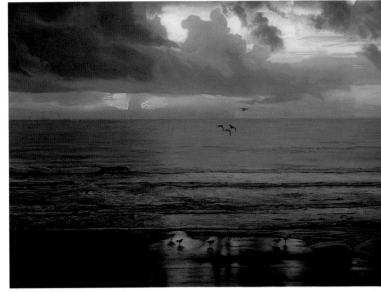

Foreword

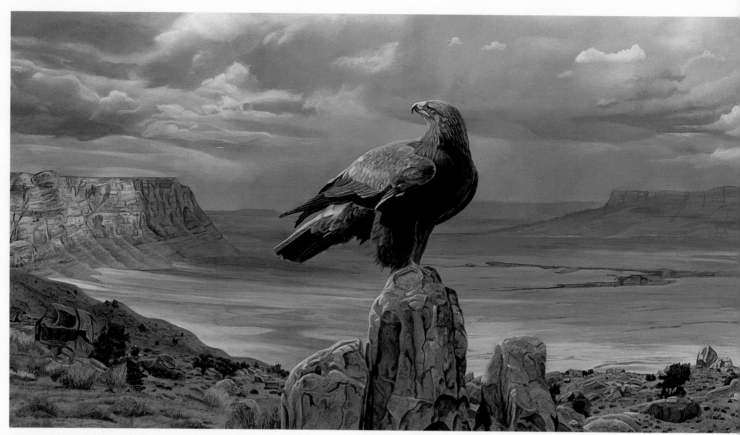

BROTHER OF THE SKY—GOLDEN EAGLE
12½″ × 40″ (31.8cm × 101.6cm)

What makes a dramatic wildlife painting? The answer is as varied as "What makes a good person?" Wildlife painting is no different from any other painting. The drama depends on choice of subject, arrangement of composition and use of light. Terry Isaac is well suited to telling the story in all of these areas.

When I first saw Terry's work during an artists' workshop critiquing session and realized he was only 28, I was speechless. Spectacular was the only word I could think of. The sweep of the landscape, the placement of the golden eagle and the play of light and shadow was drama personified. Since then his work has moved into a variety of moods and settings but it has *always* remained dramatic.

—ROBERT BATEMAN

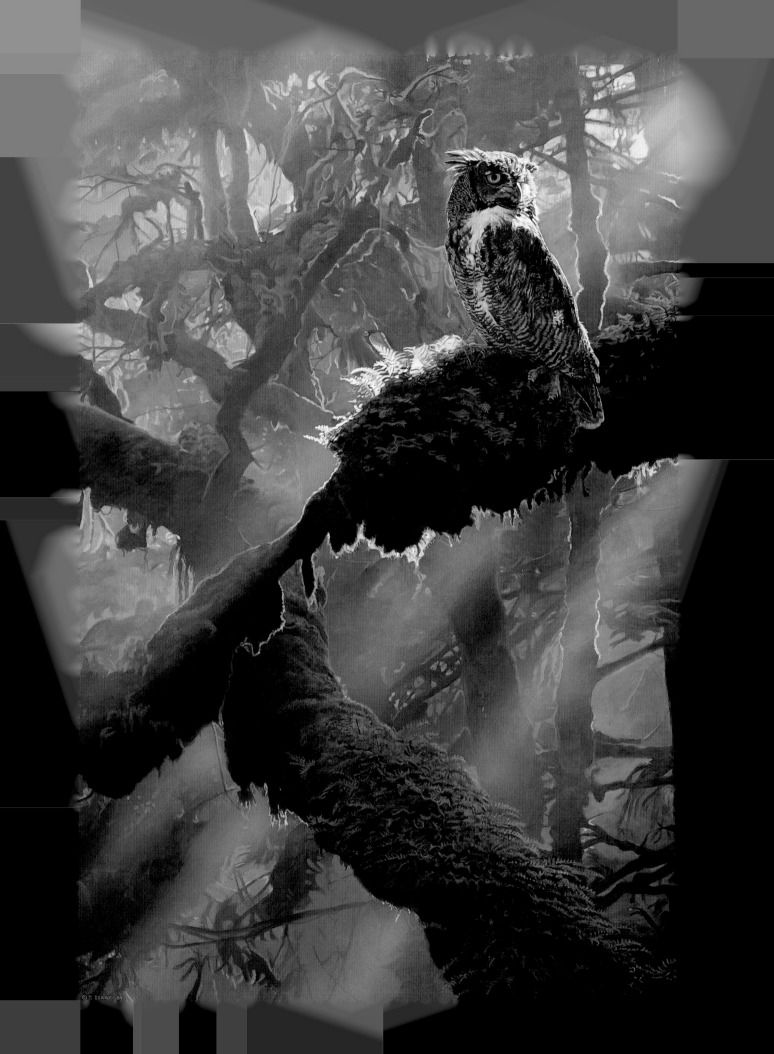
© T. ISAAC 89

Capturing Special Moments in Nature

Special moments in nature are derived from a variety of factors ranging from lighting conditions, weather and atmosphere to a particular behavior of a bird or animal. To create a dramatic painting you want to elicit an emotional response from the viewer—you want them to look at the painting and say "Wow!" This response can be achieved in many ways: exciting color, light, atmosphere, behavior, mood and freshness of idea. These ingredients all contribute to creating a dramatic painting. Often, capturing the special, fleeting moments in nature, such as a sunset or rainbow, lends drama to a painting.

CAUGHT BY LIGHT—GREAT HORNED OWL
30⅛″ × 20″ (76.5cm × 50.8cm)

CAMERA

One of the tools needed to capture those realistic moments in nature is a good 35mm camera. I highly recommend purchasing one with motor drive, which is necessary for taking photos of moving animals and birds. I also recommend a telephoto lens, 75-300mm, and a 55mm. Of course, you may want to have additional lenses and filters, but these two will get you by.

FILM

I photograph my subjects with print rather than slide film. Print film has its advantages and disadvantages. The advantage of using print film is that it gives you much more latitude in exposure. A good developer can lighten or darken, and shift colors from warm to cool to meet your specific needs. The disadvantage with print film is that usually the color is not as rich as that of slide film. But, as an artist, you can adjust your paint colors for the desired effect.

FIELDWORK

Fieldwork is where it all begins and where you will get most of your ideas, although ideas can come from anywhere. You don't need to go to exotic lands. Your own backyard is a great place to start.

In finding inspiration and ideas for dramatic wildlife paintings, you must study and observe as much as you can. Special moments in nature happen all the time. The challenge is to be in the right place at the right time. This involves planning and luck—and the realization that you will have to gather much more reference material than you will probably use. As an artist you can create dramatic lighting and atmosphere, but it is much more believable if it is something you have actually witnessed.

For me, dawn and dusk often offer the most interesting light. Low-angle light can help to produce a dramatic painting. Animals and birds tend to be more active at these times, as well. Visiting state and national parks, zoos, wildlife rehabilitation centers, and collecting material in all seasons is paramount.

For reference gathering, it is important to think ahead. My motto is "Film is cheap, experience is rich." I take background, foreground and middle-ground shots. I like everything from close-ups to panoramas. I will often take vertical and horizontal shots of the same scene. I also try to take a variety of lighting situations ranging from light hitting the front of the subject to the subject being backlit. I tend to look for scenes where an animal or bird would likely be present—in a branch or on a rock with a vantage point, or in a place where two habitats intersect, like meadow and forest, river and bank.

WORKING WITH PHOTOS

When working from photos, be aware of the principles of design and composition. Don't be afraid to alter, edit and manipulate elements to create a stronger design. The eye and camera see differently. For example, shadows tend to go black on film, while your eye may actually see some detail and a variety of colors in them. Photos of backlighting situations tend to become white or to burn out, but the eye may see color and detail in the backlit areas. Also, foreshortening becomes a problem when using a telephoto lens. When working with several photos for one painting, create a subject and scene with a single light source. Most important, when coming up with a painting concept, think through what you want to convey to the viewer.

USING OTHER REFERENCES

In addition to taking your own pictures, I highly recommend you keep and maintain a "morgue" file. This is a file of photos taken from magazines, ranging from specific animals and birds to landscapes. I also keep files of articles on wildlife "hot spots" for locations and travel, as well as articles that give me indepth information about subjects that I might want to paint.

It is also important to have as many reference books as you can afford and have bookshelves to hold. Libraries and used bookstores are great sources of wildlife information. I also keep a collection of wildlife videos recorded from interesting programs on television. The more information you have available to you, the better your paintings will be.

I sometimes make clay models of the subjects I paint, in order to understand lighting when my photo reference does not give me enough information. I have used study skins and frozen birds to enhance my understanding of a bird or animal. Often these specimens can be borrowed from schools, universities and museums. Wildlife rehabilitators and taxidermists can also help you to better understand your subjects. Establish a mutually beneficial relationship with the wildlife resources in your area. As an artist, you have much to offer. Most important, you'll be benefitting wildlife.

Planning a Composition

In the planning stage, I review my references and see what speaks to me, what seems most magical. I usually come up with many ideas and discard the ones that aren't as strong or don't seem unique, fresh or interesting to look at. Often my painting ideas begin with a scene or combination of scenes that have a special quality of lighting, atmosphere or mood. Then I think of what animal or bird would best fit into that environment. I also make sure of seasonal characteristics. For example, you wouldn't want to paint an animal in a winter scene with a summer coat, or a bird in breeding plumage in an inappropriate season. The subject and setting must go together, and the setting should be appropriate for the species depicted.

My paintings are often composites of several references combined to create a scene. It is important to work from a variety of reference materials, because one reference may not contain all the ingredients needed to create an exciting painting. But remember, less is more. Edit, edit, edit!

Once I decide on a painting concept, I make several thumbnail sketches. I try some vertical designs and some as horizontals, and a variety of formats and subject placements. When choosing the format, think of the personality and habits of the animal—does it live in a horizontal or vertical world? For example, is it an eagle with sweeps of sky available, or a mountain goat perched on a precarious ledge?

Generally I choose a smaller format for smaller animals and birds, and larger formats for larger species. Often I like to paint birds or smaller animals life-size. I strongly urge you to make thumbnail sketches before you actually begin painting. It is much easier to see a problem and correct it when it's a small sketch than to be halfway through a major painting and realize you've made a huge mistake.

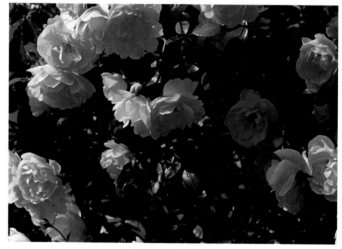

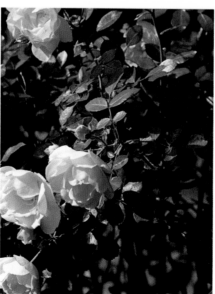

Combining Reference Photos
Here is an example of various reference photos combined to make a single painting. In *Millie's Garden*, shown on page 16, I was first intrigued with the white picket fence and roses, but didn't like the roses that were actually near the fence. I went on a photographic quest for other rose references and felt better about those shown here. I also liked the idea of a rose coming through the fence and used a different rose reference than the one in the picket-fence photo. I drew several thumbnail sketches until I arrived at the design I chose to paint.

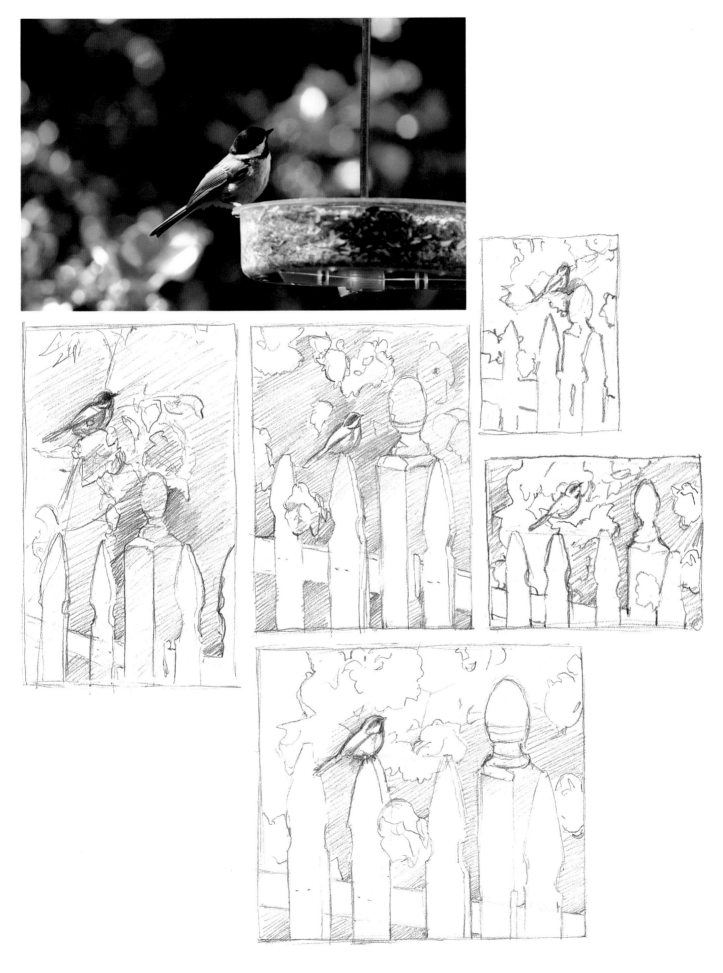

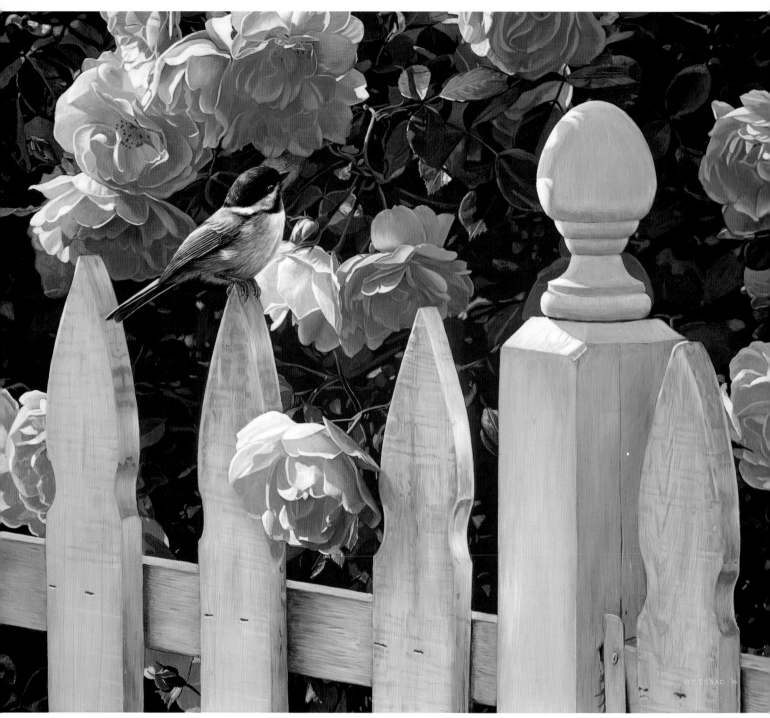

MILLIE'S GARDEN
15½″ × 18½″ (39.4cm × 47cm)

Trying Vertical and Horizontal Formats

In *The Summit*, shown on page 18, I combined a mountain background with foreground rocks and snow. In my reference there was actually a lynx crouching among the rocks instead of wolves. I drew some thumbnail sketches first and decided on a vertical format for the painting. In chapter two I will demonstrate how I painted a section of the rocks and snow.

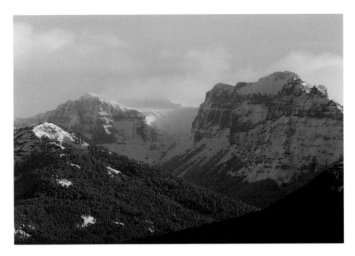

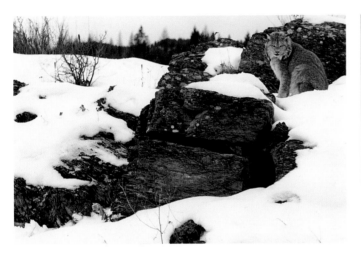

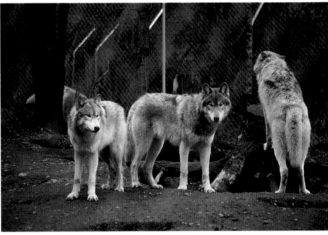

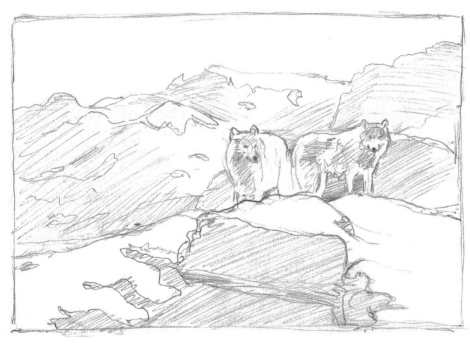

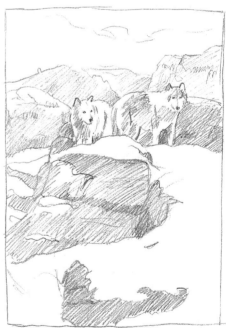

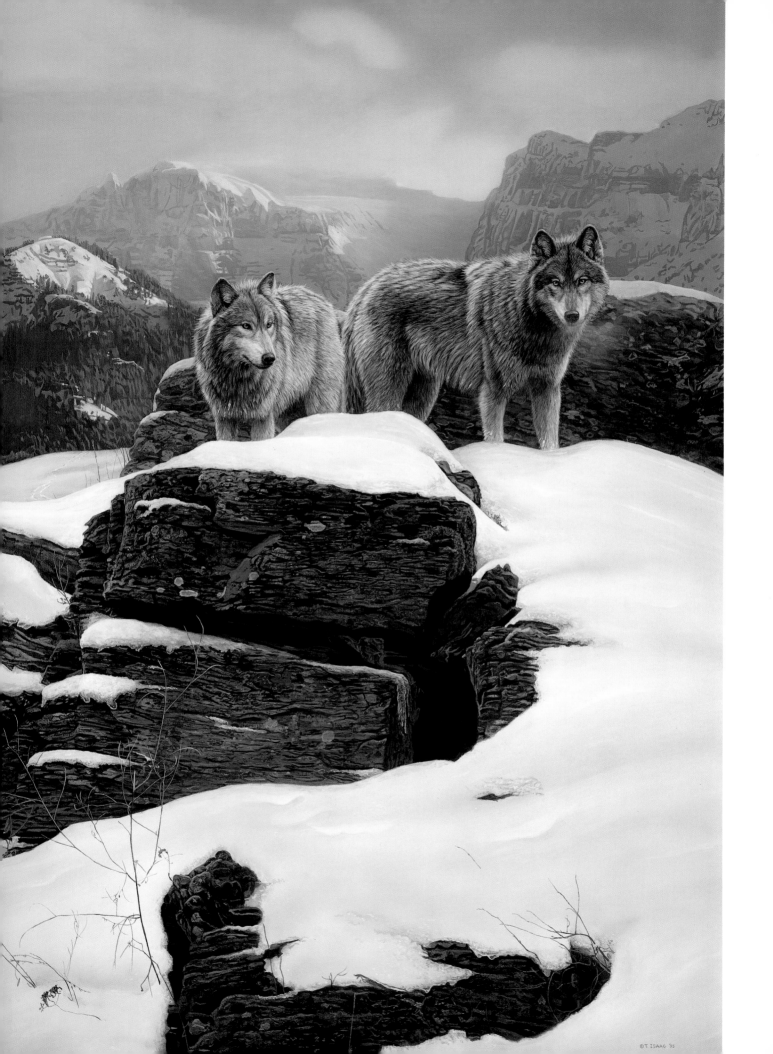

©T. ISAAC '95

Sometimes it can be beneficial to make a study painting, which should be much smaller than the final painting. Studies are helpful to visualize how the larger version will look. It is much easier to correct a problem in a small piece than to re-work a major piece, but sometimes that, too, is necessary. I have sanded areas off and even sawed off sections if I felt the design could be improved.

at left
THE SUMMIT—WOLVES
36" × 25¾" (91.4cm × 65.4cm)

Starting With a Small Study

Usually, a particular setting inspires the idea for a painting, but occasionally it's the subject and pose that inspire the concept. In *Above Timberline*, shown on page 21, I began with the wolves. First I made a small study painting and left the background area vague. Later I went to Baffin Island in the Canadian Arctic and photographed the arctic tundra and mountain settings shown on page 20. I thought it would be a good idea to combine the wolves I had painted earlier with a Baffin setting of mist and cloud-shrouded mountains. I drew some thumbnail sketches, combining the various elements, and then completed the painting.

© T. ISAAC '89

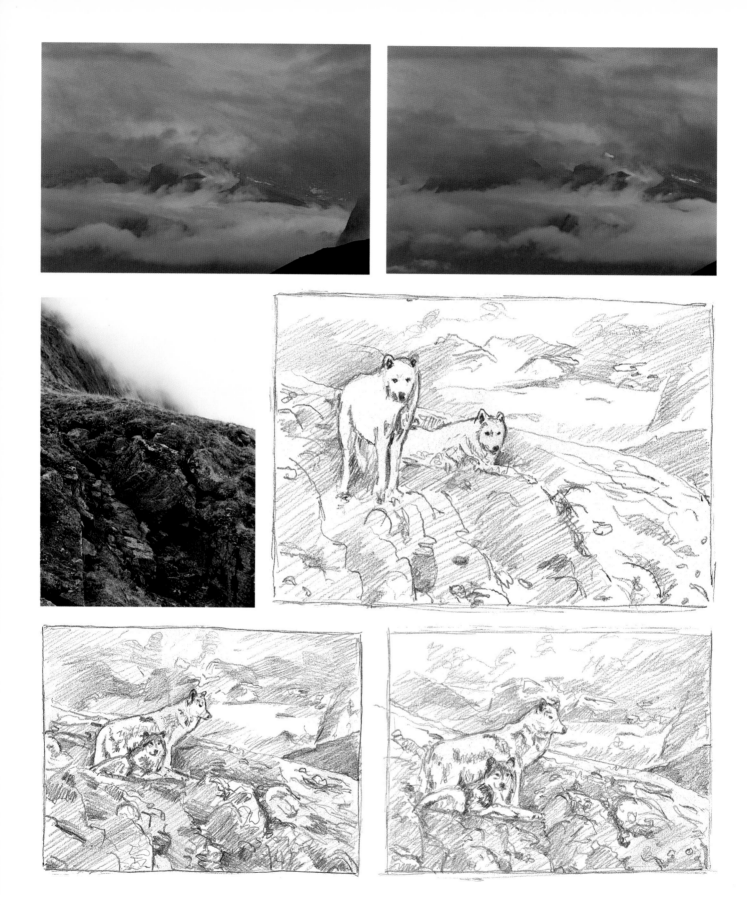

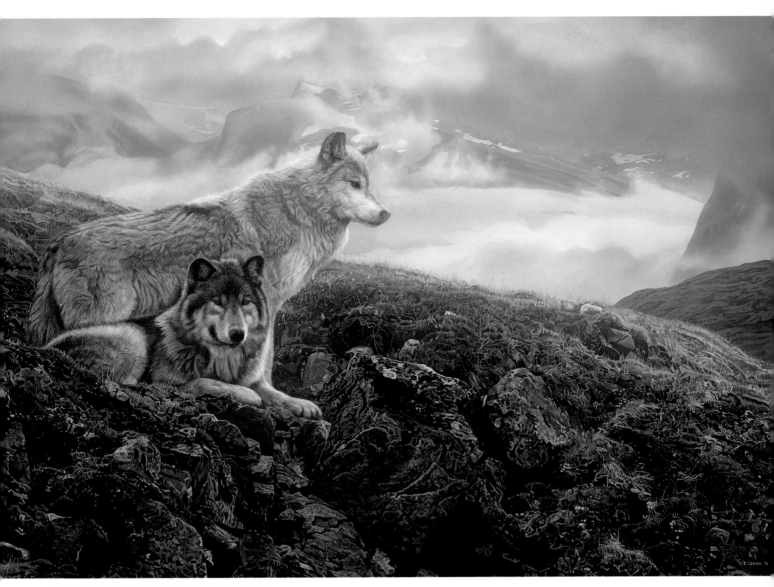

ABOVE TIMBERLINE—GRAY WOLVES
24″×36″ (61cm×91.4cm)

Composition Do's and Don'ts

Keep in mind that rules can be broken, but these tips may be helpful to think about when drawing up your design:

- *Do* capture the natural world the way it really is rather than arranging a "cooked-up" or stereotypical look out of your imagination. That is why firsthand observation for painting ideas is so important. Use correct perspective; for example, waterfowl on a watery surface should be smaller in size as they go back in the picture plane. They should also look like they are on the same plane of water. However, *don't* be afraid to change things you observe to create a better design.
- *Do* have a clear focal point in the painting. *Don't* have conflicting centers of interest. Avoid having two elements the same shape or volume without making one subordinate to the other. You can have a primary focal point and a secondary focal point, but two primary focal points will fight for the viewer's attention.
- *Do* use the "rule of thirds" for placement of your subject. This simply means to divide your format in thirds horizontally and vertically; where intersections occur might be a good place for the main subject. *Don't* place all your interesting elements in the middle of the composition.
- *Do* balance your painting visually, but *don't* divide the painting in half with pictorial elements, vertically or horizontally. Informal balance or an unstable composition may be more interesting. Negative space can be used to balance the main subject.
- *Do* subordinate background areas with harmonious value and color, particularly around the main subject, to avoid distraction. *Don't* create spatial tension that distracts from the focal point. For example, if you place a bright grass blade almost, but not quite, touching an animal, the space between the animal and grass blade becomes energized, or visually weighted, and tends to draw the viewer's eye.
- *Do* create shapes and values to help the viewer's eye move through the painting, as well as areas where the viewer's eye can rest. *Don't* lead the viewer's eye where it shouldn't go. Visually weighted or "arrow" shapes might carry the eye right out of the painting. Converging lines may also draw too much attention.
- *Do* attempt to create a coherent arrangement of visually stimulating shapes and values. The piece should work well as an abstract without regard to surface detail. Think of your painting as a jigsaw puzzle. If you were to eliminate the detail, does your painting have interlocking shapes, colors and values? Does your eye move well through the piece as you are viewing it? *Don't* have confusing patterns and overall busyness.
- *Do* space things out unevenly—making them different sizes and shapes. Try to create areas that move from dark to light, gray to color, large to small, bright to dull, warm to cool. This will make your painting more interesting to look at. *Don't* use static shapes or wildlife poses, or make everything the same size.
- *Do* remember that "light against dark" and "dark against light" will emphasize dominant centers of interest, but *don't* have a color, value, texture or angle change behind a subject. For example, if you're painting a wolf, *don't* have a background rock dark on one side of the leg and light on the other side. Strive for continuity behind objects.

Again, keep in mind rules can be broken but they can also be a starting point when creating art.

Balance and Repetition

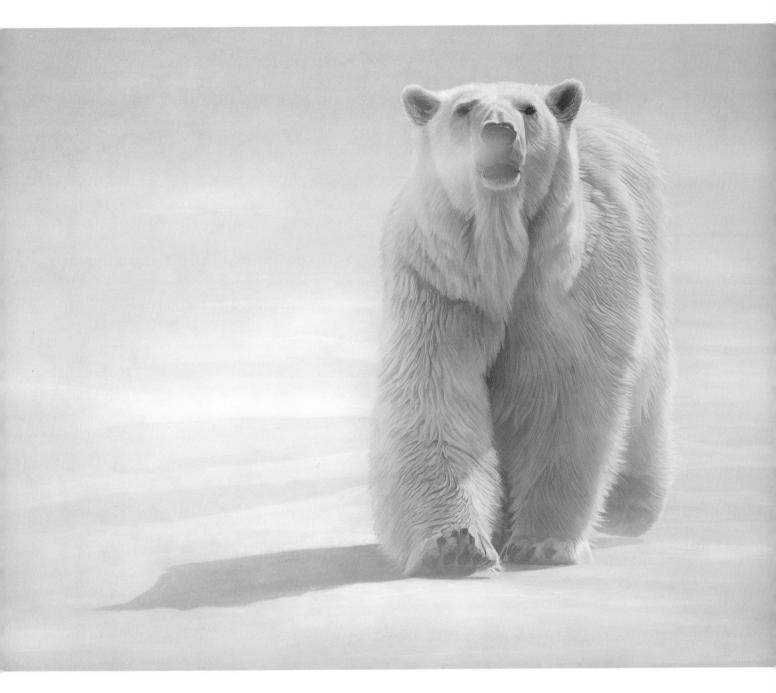

Art has its own vocabulary. When we are looking at a piece of art, we are really looking at how an artist has utilized the *elements* and *principles* of design. The elements are the physical aspects of a work: line, shape, value, texture, color, and form or mass. The principles are what these physical aspects create: balance, rhythm, repetition, contrast, dominance, harmony, unity, pattern and variety. A design is a thoughtful selection and arrangement of the visual elements within a contained space. Entire books are written about these aspects, and I couldn't write a book about painting without at least mentioning them. My goal as an artist is to create good paintings, considering these design aspects, regardless of my painting's subject matter.

FACE-OFF—POLAR BEAR
26⅝" × 40" (67.6cm × 101.6cm)

Visual Balance

Visual balance can be divided into several categories: color, shape, texture and value. Essentially there are three kinds of balance: symmetrical, asymmetrical and radial. *Face-Off* is an example of asymmetrical balance. The large amount of negative space balances the visual weight of the polar bear.

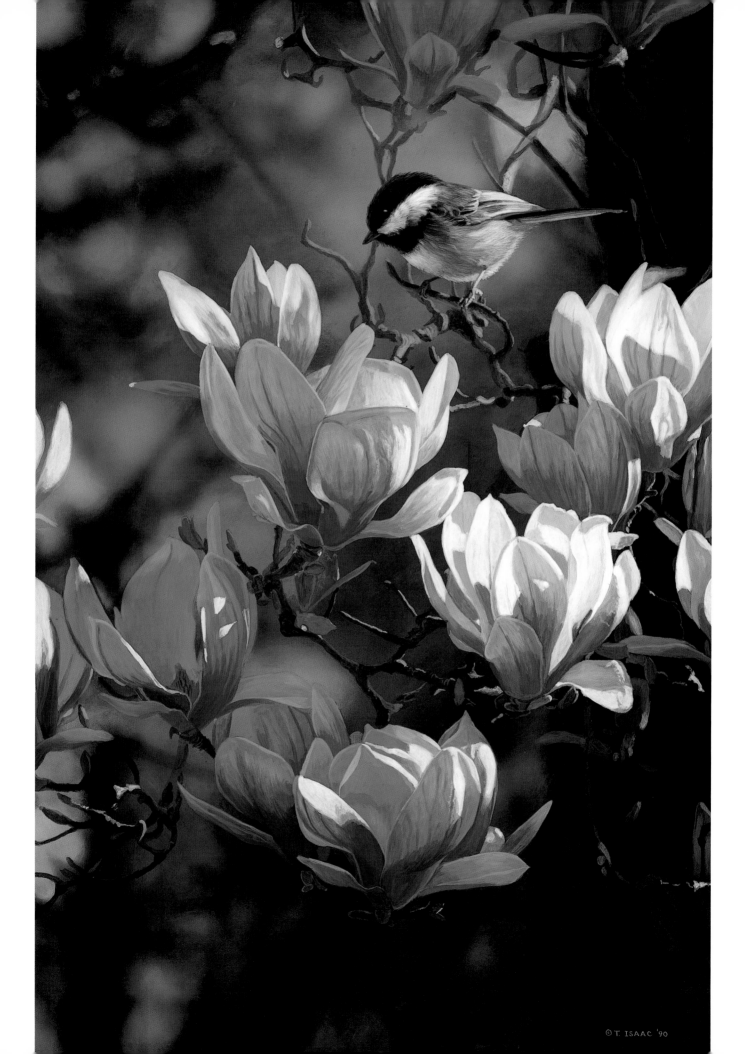

© T. ISAAC '90

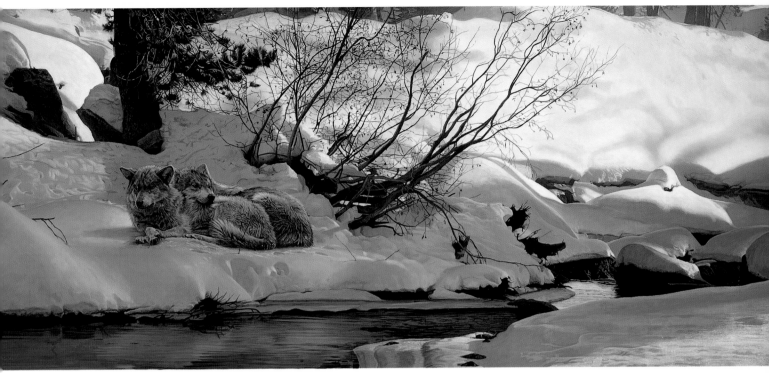

Completing a Circle or Line

Other aspects to consider when placing the subject in a scene is the visual completion of a circle, the continuation of a line or the completion of a geometric shape. The painting *In the Pink* demonstrates a clear example of completing a circle: The blossoms carry the viewer's eye from the chickadee, around to the lowest blossom and back up to the chickadee. *The Good Place* illustrates the completion of a line: The viewer's eye travels in a straight path from the dark rocks and tree at left, through the wolves and bare branches to the rocks and shadows at the right.

at left
IN THE PINK—BLACK-CAPPED CHICKADEE
12″ × 18″ (30.5cm × 45.7cm)

Repetition

Repetition helps to add unity and rhythm to a piece of art. In *Brambles and Brass Buttons* the scaled appearance of the feathers on the underside of the quail repeat the scaled texture of the blackberries.

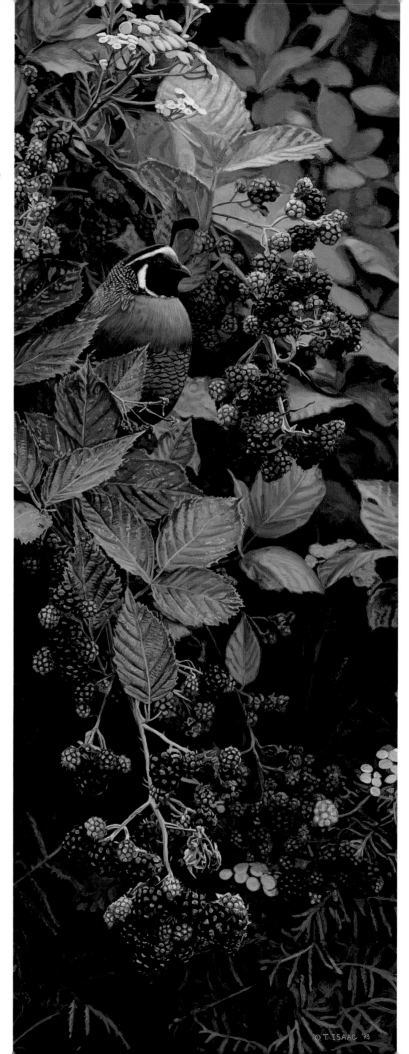

BRAMBLES AND BRASS BUTTONS—
CALIFORNIA QUAIL
24″×9″ (61cm×22.9cm)

Getting Started

With good reference material in hand and a great concept in mind, it's time to start painting. I first prime my painting boards—¼" (6mm) untempered Masonite—with Grumbacher gesso mixed with Liquitex acrylic Payne's Gray and Raw Umber to create a neutral gray. I use a Robert Simmons 721 flat 1½-inch (38mm) brush to apply the ground. I dilute the gesso mixture with water and paint a total of six coats, sanding with #220 sandpaper every other coat. I also use a hair dryer to expedite the process.

My palette is made up of Liquitex acrylic paints. Almost 90 percent of my paintings are created from these colors: Payne's Gray, Burnt Umber, Titanium White, Raw Umber, Ultramarine Blue, Chromium Oxide Green, Raw Sienna and Burnt Sienna. The other 10 percent include a variety of colors of different hues and/or greater color saturation, such as Vivid Lime Green and Cadmium Orange.

When beginning a painting there are many things to think about. One of the most critical is learning how to mix colors. It is important to understand color has three aspects: *Hue* refers to the actual name of the color and its placement on the color wheel. *Value* is the relative lightness or darkness of a color. *Intensity* is the brightness or dullness of a color. Then there are *tints* (colors mixed with white), *tones* (colors mixed with gray) and *shades* (colors mixed with black).

To apply these paints, I use a variety of Richeson watercolor brushes, both flats and rounds.

Other essential tools I use are natural sponges, toothbrushes and an Iwata HP-C dual-action airbrush with a compressor. For scumbling (see page 87), I use worn-out brushes, so it is important to save some that have frayed.

To finish my artwork, I use Liquitex Gloss Medium and Varnish, which I apply with an airbrush. I first dilute it with water and sift it through an old nylon so that there are no lumps. I apply several coats to achieve a satin look. This gives an even, permanent finish that I can paint over if the urge arises. There are also commercial varnish sprays for acrylic paintings. These are removable with solvents. It would be a good idea to consult with an art store to get the best product for your purposes and particular medium. Pay careful attention to the safety warnings on the label.

Another consideration is appropriate studio space. This is a place where you can work without distraction, with good lighting, and where you can leave your work out without having to put everything away when you are done for the day. Set up a space that is comfortable and inviting.

Here is my studio setup.

Some basic supplies.

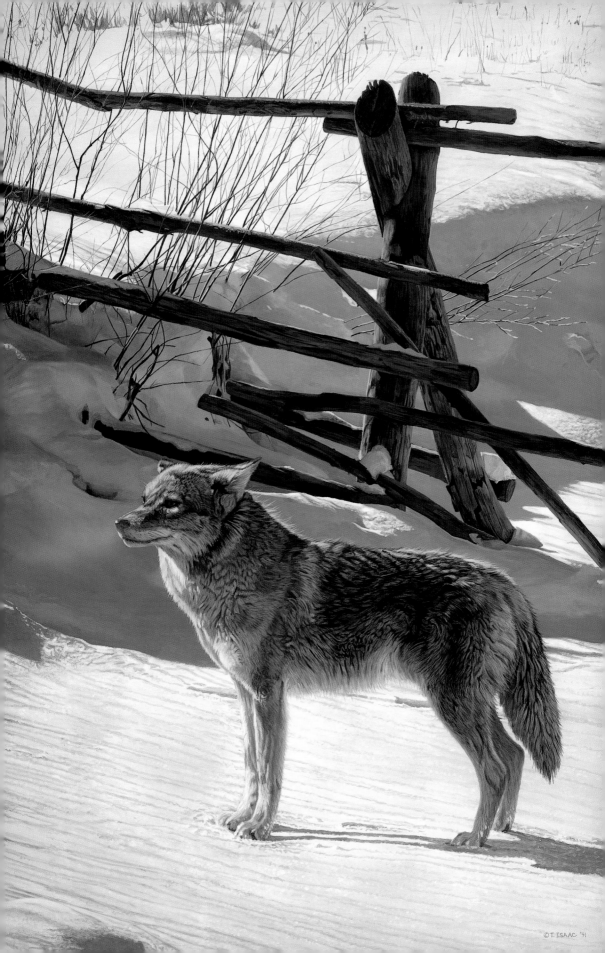

Creating Nature's Textures Step by Step

To create realistic, accurate wildlife paintings, you must study your subjects in their natural habitat. Strive to capture the characteristics of the subject and its environment. Watch for unique behavior. Spend time in the field studying typical poses and gestures. Think about the behavior and attitude you're trying to convey with the subject, such as resting, feeding, surprise, fright, sleepiness. Reading about your subject is also essential. The more knowledge you have of your subject, the better approach you will have to painting it.

RAILFENCE—COYOTE
24" × 16" (61cm × 40.6cm)

Fur

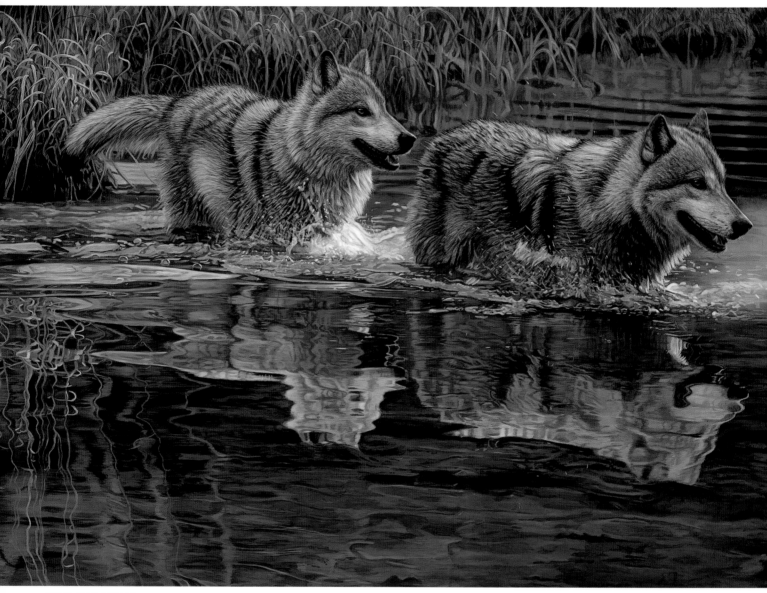

THE CROSSING
21½″ × 36″ (54.6cm × 91.4cm)

Start With Accurate Proportions

When painting feathers and fur, your first concern is getting the anatomy correct. Both feathers and fur are essentially surface detail over an underlying structure. Proportions must be accurate. One of the easiest ways to check basic proportion is to use the head as a unit of measure when calculating the height or width of an animal or bird.

1 To create the fur texture shown in *The Crossing*, start with a base color. I use Neutral Gray Value no. 5, Payne's Gray, Raw Sienna, Burnt Umber and Titanium White, applying the paint with a Richeson no. 10, series 9050 brush.

2 Begin to paint the structure and direction of the fur. Lay in the basic darks and lights using the brush and paints mentioned in step one. Apply your brushstrokes in the appropriate direction of the fur.

3 Begin refining as you continue to paint the lights and darks and the linear detail. I use different brushes at this stage—the Richeson no. 3, series 9000 and the Richeson no. 6, series 9050. In addition to the other colors mentioned, I use Unbleached Titanium White.

4 Continue to refine and add detail, painting more and more individual hairs with both light and dark values.

Wet Fur

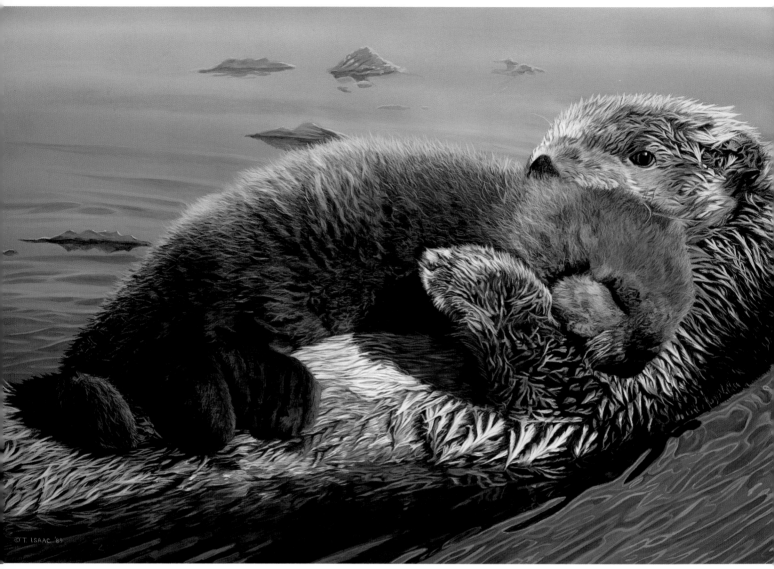

ROCKABYE—SEA OTTER
13½" × 22½" (34.3cm × 57.2cm)

Tips on Painting Fur

Fur and feathers on various parts of the body are different lengths and textures. The fur on mammals tends to be short on the muzzle and longer on the top of the head and around the ears. When painting fur, think of it as painting a landscape with hills and valleys. Remember that what is under the fur (skin, muscles and bone) is reflected in how the fur lays on various body planes. Don't stylize feathers or fur—strive to capture the particular appearance of the various areas you are painting. Also be aware of seasonal changes in length and color of fur.

1 I use the following steps to paint the wet fur on the mother otter at left. Begin with a base color of Ultramarine Blue, Raw Umber, Payne's Gray, Burnt Umber and Titanium White, using a Richeson no. 10, series 9050 brush to apply the paint.

2 Paint the lighter values on top of the darker base. The brush I use for the smaller lines is the Richeson no. 4, series 9000. For the larger, lighter groupings of fur I use the Richeson no. 6, series 9050. In addition to the above colors, I include Raw Sienna. Notice how the wet fur clumps together, forming a sideways V shape.

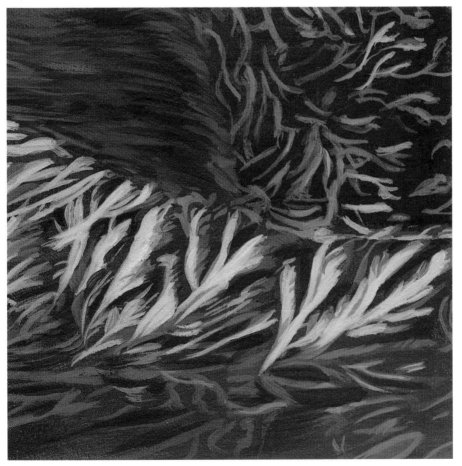

3 Continue to build detail and structure, layering the detail on top. I use the Richeson no. 4, series 9000 for the finer strokes. As you work, turn the painting upside down and sideways so that the brushstrokes come toward you as you paint them. To create a finer tip on the end of each painted hair, lift up on the brush as you approach the end of the hair shaft.

Patterned Fur

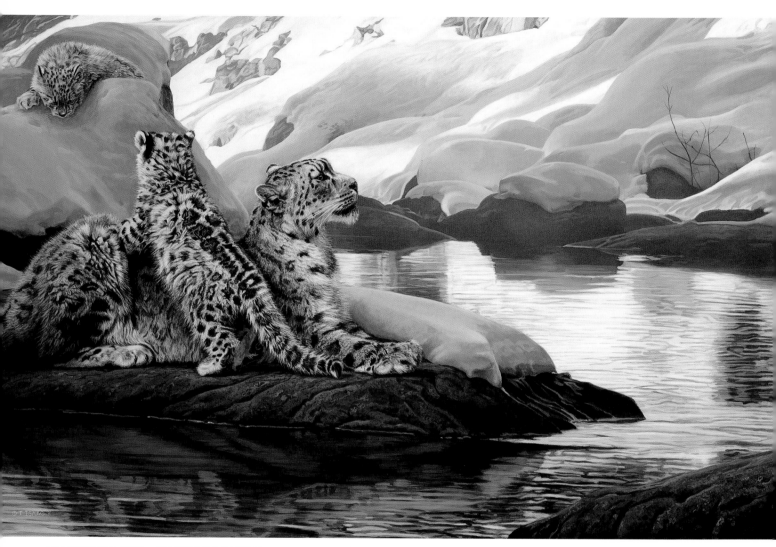

WATCHFUL EYE—SNOW LEOPARDS
17½" × 36" (44.5cm × 91.4cm)

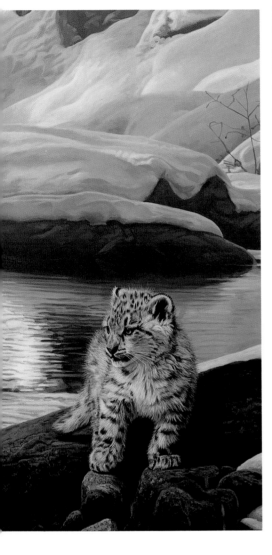

1 To paint patterned fur, begin with a base color of Ultramarine Blue, Raw Umber, Payne's Gray, Burnt Umber and Titanium White, applied with a Richeson no. 10, series 9050 brush.

2 Layer the fur's basic color and value on top of the base color. Use the base as a midtone and paint the lights and darks on top. The brushwork is done with a Richeson no. 6, series 9050. For the light values and color use Titanium White, Raw Umber, Unbleached Titanium White and Raw Sienna. For the dark values use Payne's Gray, Burnt Umber and some Ultramarine Blue, which is a reflected color from the snow and sky. Be careful to paint the brushstrokes in the direction of the fur.

3 Refine and add more detail with the Richeson no. 4, series 9000 brush. I establish the darks and lights with additional layers of paint, building up an opaque surface and eliminating the look of watercolor washes. I keep the lightest values of fur on top, where ambient light is hitting, to show the form of the snow leopard.

White Fur

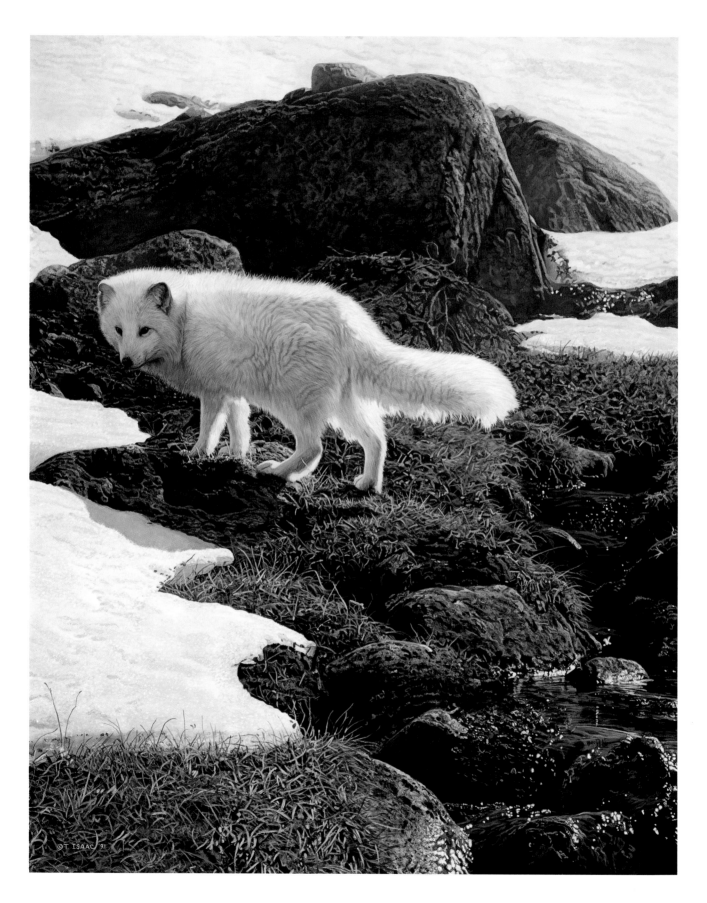

1 To paint white fur, begin with a Richeson no. 10, series 9050 brush and apply a mixture of Cerulean Blue, Ultramarine Blue, Raw Umber, Payne's Gray, Burnt Umber and Titanium White.

2 Block in the basic lights and darks. White fur is very reflective—much of the color I added to the fur in the painting at left is a reflection of the sky and tundra where the arctic fox is standing. The fox is back- and sidelit, so we see both direct light and reflective light (or bounce light) affecting the light on the fur. I use Light Portrait Pink in the transition area from the highlighted fur on top to the shadowed area below. The highlighted fur is a mixture of Titanium White and Unbleached Titanium White. The shadow area is a blend of Cerulean Blue, Raw Umber, Payne's Gray and Titanium White. Use a Richeson no. 6, series 9050 brush to apply the strokes in the fur's direction. Suggest fur detail at this point.

at left
ARCTIC SUN—ARCTIC FOX
20″×16″ (50.8cm×40.6cm)

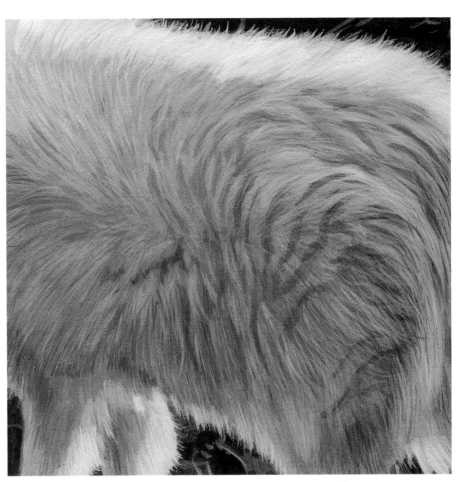

3 Using a Richeson no. 4, series 9000 brush, establish final detail and refine the fur structure.

Wolf Eye

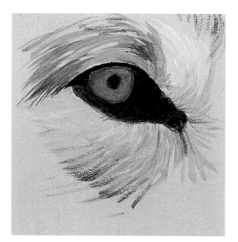

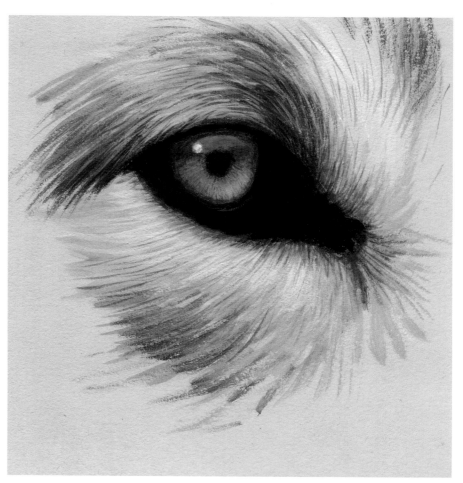

1 The eyes of the subject are the most important feature—they show life. Eyes and the surrounding facial area help communicate what the animal is feeling: fright, contentment, sleepiness, alertness, anger. The amount of light hitting the eye of the subject will impact highlight, reflective light and pupil dilation. On an overcast, dark day, you would not want to paint a bright highlight. Nor would you want to paint a large pupil with a lot of light hitting the eye. Eye placement and size are critical in achieving the right look of the animal or bird you are painting. Begin by drawing a basic outline of the eye and fur direction.

2 Start to block in basic values and colors. I use a Richeson no. 6, series 9050 brush to apply Raw Umber, Titanium White, Payne's Gray and Burnt Umber.

3 Establish lighting on the eye coming from the top left. Darken the top of the eye where the brow area is casting a shadow and lighten the bottom area where light has passed through. Paint the top part of the eye with Ultramarine Blue and Payne's Gray and add a white highlight from the sun. The bluish cast is a reflection of the sky. Paint a rough edge around the pupil; a hard edge would give your animal a cartoon-style look. On the opposite side of the eye from the highlight, lighten the bottom of the iris area with Turner's Yellow and some Titanium White. Paint a spokelike texture toward the center of the eye. The bluish area on the top of the eye helps create the illusion of a moist, reflective surface. For the eye and fur detail I use a Richeson no. 4, series 9000 brush.

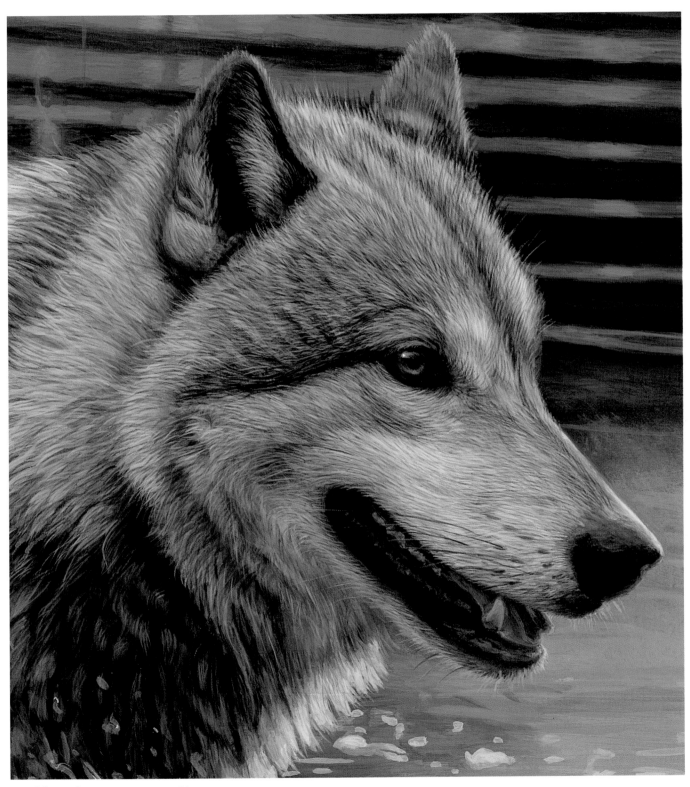

Detail from *The Crossing* on page 30.

Feathers

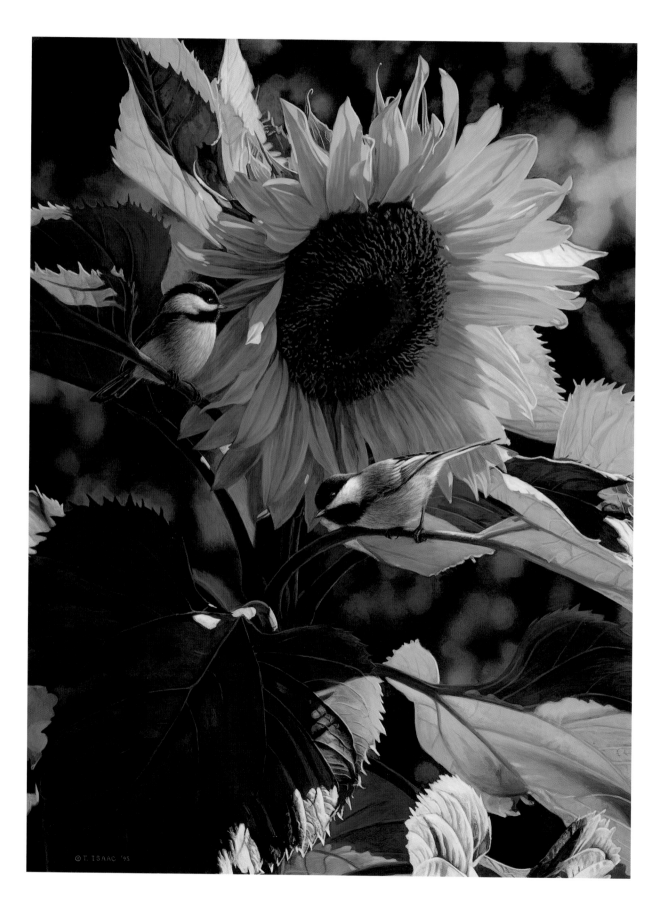

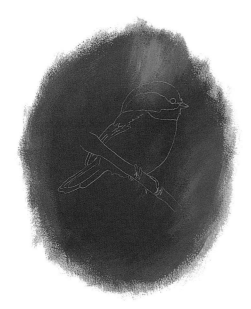

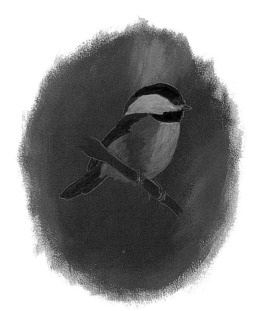

1 To paint this little chickadee, begin with a base color to approximate the tone and color of the background of the complete painting. I use Chromium Oxide Green, Payne's Gray, Burnt Umber, Turner's Yellow, Vivid Lime Green and Ultramarine Blue. I use a Richeson no. 10, series 9050 brush to apply the paint. I drew my chickadee on tracing paper, then transferred it over the base color, using white graphite paper.

2 Block in the basic colors and values of the chickadee. The colors I use are Raw Sienna, Burnt Umber, Payne's Gray, Titanium White, Unbleached Titanium White, Ultramarine Blue, Turner's Yellow and Vivid Lime Green. I use a Richeson no. 6, series 9050 brush to paint the brushstrokes, going the same direction as the feathers.

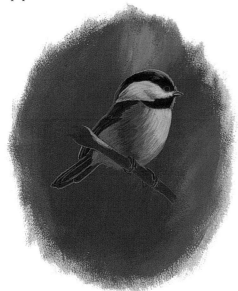

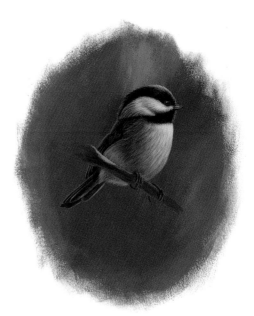

3 Model the chickadee, putting in lights and shadows. Start to indicate more feather texture and detail.

4 Continue to refine using the Richeson no. 4, series 9000 brush. When painting any subject into a setting, try to keep the lighting consistent. Also think of how the environmental colors and light will impact the look of the subject. Notice the yellow-lime green color on the lower bottom area of the chickadee that represents the bounce light and adjacent color from the illuminated sunflower. Painting light on dark and dark on light will help the subject stand out against the background.

at left
SUNBATHERS—BLACK-CAPPED CHICKADEES
21″ × 15¾″ (53.3cm × 40cm)

Leaves

1 I use the following steps to paint the leaves in the painting on page 40. For the base color, use a mixture of Chromium Oxide Green, Payne's Gray, Ultramarine Blue and Burnt Umber applied with a Richeson no. 10, series 9050 brush. After you paint the base color, transfer the basic outline of the leaves with white graphite paper.

3 For the final step, add leaf vein detail and continue to refine all areas. Make some areas more opaque and eliminate the "brushy" look.

2 Begin blocking in basic colors and values. The colors I use are Titanium White, Yellow Medium Azo and Vivid Lime Green for the leaves. For the other areas I use the colors from step one. I use the Richeson no. 6, series 9050 brush for larger areas and the Richeson no. 4, series 9000 brush for smaller areas.

Detail from *Sunbathers* on page 40.

Grass

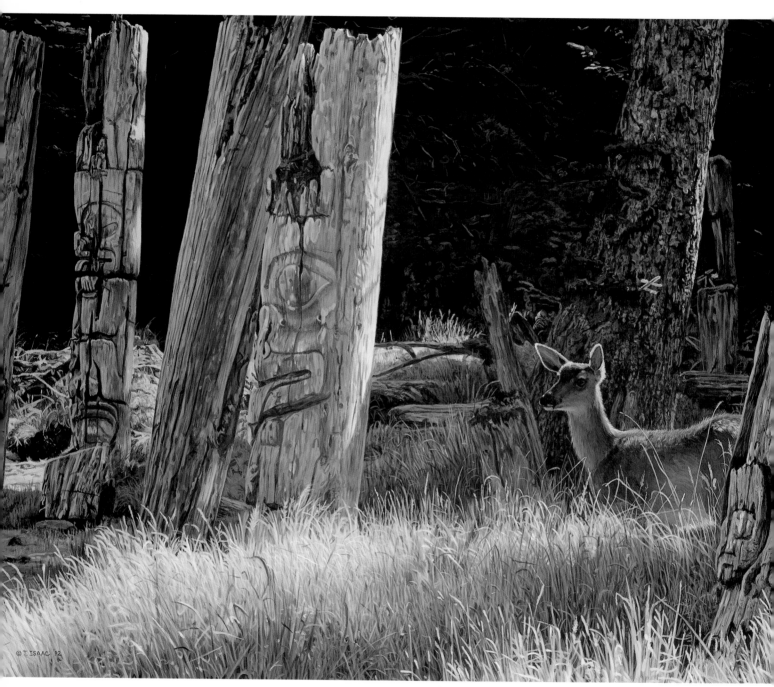

HAIDA DREAMS
16″×24″ (40.6cm×61cm)

1 To paint the grass in the scene at left, begin with a base color of Chromium Oxide Green, Ultramarine Blue, Payne's Gray, Burnt Umber and Titanium White applied with a Richeson no. 10, series 9050 brush. Leave the brushstrokes rather streaky for the understructure of the grass. The strokes are vertical, following the growth direction of the grass.

2 Block in the basic lights and darks using a Richeson no. 6, series 9050 brush. I add in some new colors at this point: Cadmium Orange, Vivid Lime Green, Yellow Medium Azo and Turner's Yellow. Start to create the linear look of the grass.

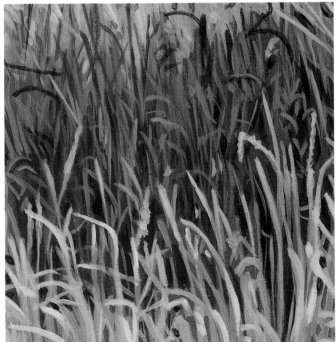

3 Add more detail and glaze over areas with transparent washes. I use both the Richeson no. 4, series 9000 and no. 6, series 9050 brushes during this final stage. In addition to the colors listed above, I add Burnt Sienna. Brighten up the lit areas and paint dark windows between grass blades. I also add Raw Sienna to the lighted grass blades. Glaze the darker area with a dark wash to minimize the contrast in the shadowy areas.

Clouds

PACIFIC PATTERNS
14⅛" × 36" (35.9cm × 91.4cm)

1 To paint the clouds in the painting above, start with a base color of Dioxazine Purple, Ultramarine Blue, Payne's Gray and Titanium White applied with a Richeson no. 10, series 9050 brush.

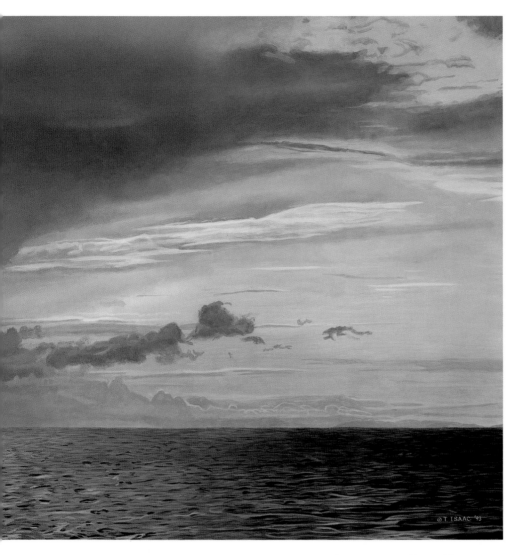

2 Block in the light values on top of the base color. Use the Richeson no. 6, series 9050 brush and Light Portrait Pink, Unbleached Titanium White and Raw Sienna. Establish the basic shapes and cloud outlines.

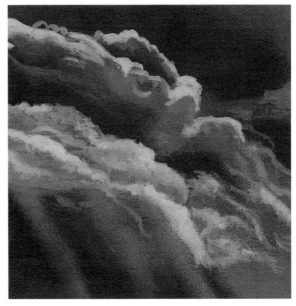

3 Using an old frayed brush, scumble in (essentially using a dry-brush technique) the light beams and soft texture of the clouds. For this, I use an old, Winsor & Newton no. 8, series 550 brush and the same colors as in step two.

DEMONSTRATION TEN
Water

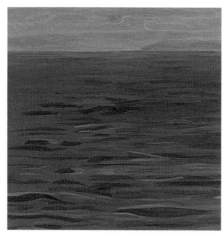

2 First glaze a transparent wash of Raw Umber and Raw Sienna with the Richeson no. 10, series 9050 brush over both water and sky. Then, using the Richeson no. 6, series 9050 brush, block in basic lights and darks on top of the base colors. At this point I use the Richeson no. 4, series 9000 brush and add detail, primarily the light edging on distant clouds and the lines on the tops of the waves.

1 I use the following steps to paint the water in the painting on pages 46-47. For the base color use a combination of Payne's Gray, Titanium White, Ultramarine Blue and Dioxazine Purple. I use the Richeson no. 10, series 9050 brush to apply these colors to the water area. For the small area of sky I use Raw Sienna, Unbleached Titanium White, Cadmium Orange and a touch of the other colors mentioned, applied with the same brush. Use horizontal strokes for the paint application.

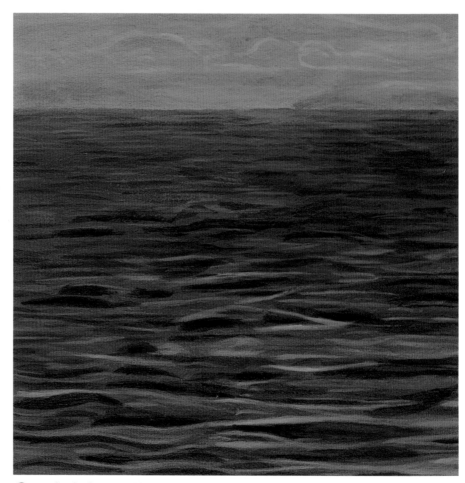

3 For the final stage, add detail and refinement. I create more contrast in the foreground water and also make the wave shapes larger in the foreground. Conversely, I compress the wave shapes and minimize the contrast in the background to enhance a sense of depth. I use the Richeson no. 4, series 9000 brush and all the above colors.

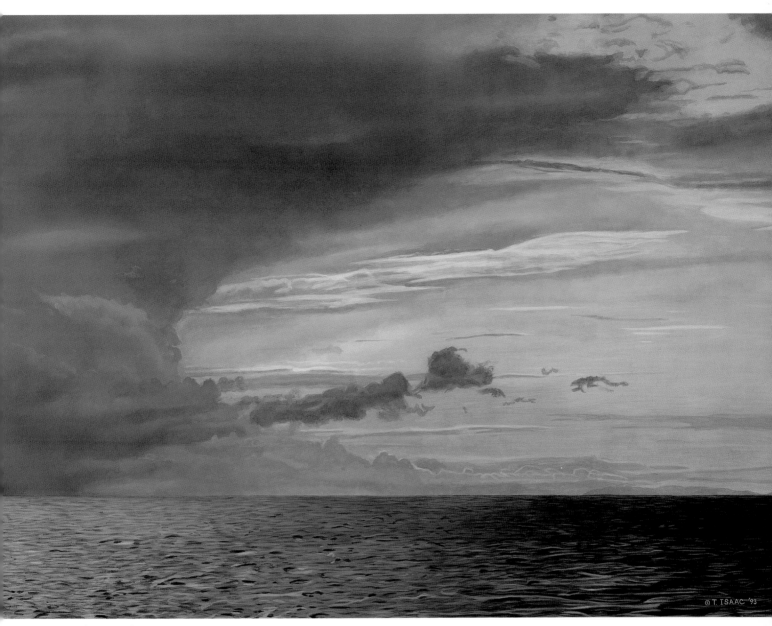

Detail from *Pacific Patterns* on pages 46-47.

Waterdrops

1 In this demonstration I will illustrate how to paint waterdrops of three different sizes. Begin by drawing the shapes.

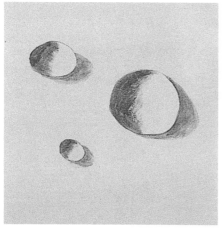

2 Waterdrops are transparent, therefore they should be the color of the surface on which they sit. In this example I use my primed board for that color: Payne's Gray, Raw Umber and the white of the gesso. Block in the basic values of the waterdrops with a Richeson no. 6, series 9050 brush.

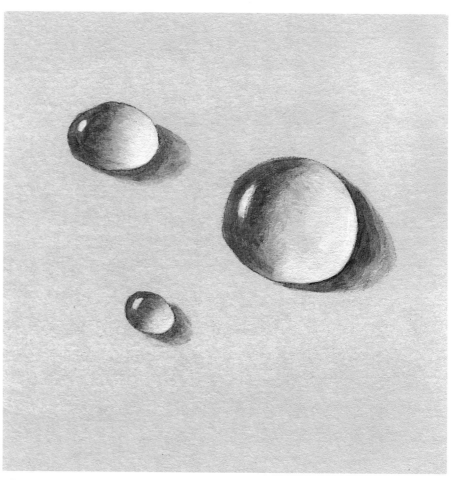

3 In the final stage, paint the highlights with Titanium White and a Richeson no. 4, series 9000 brush. Using the Richeson no. 6, series 9050 brush, paint the lighter values in the drops with Titanium White. These lighter values should fall on the opposite side from the highlight. In this regard, painting waterdrops is similar to painting eyes. Using Payne's Gray, darken the shadow area right next to the drop. As the shadow moves away from the drop, lighten its value and soften the edge so that the sharpest shadow edge is closest to the drop.

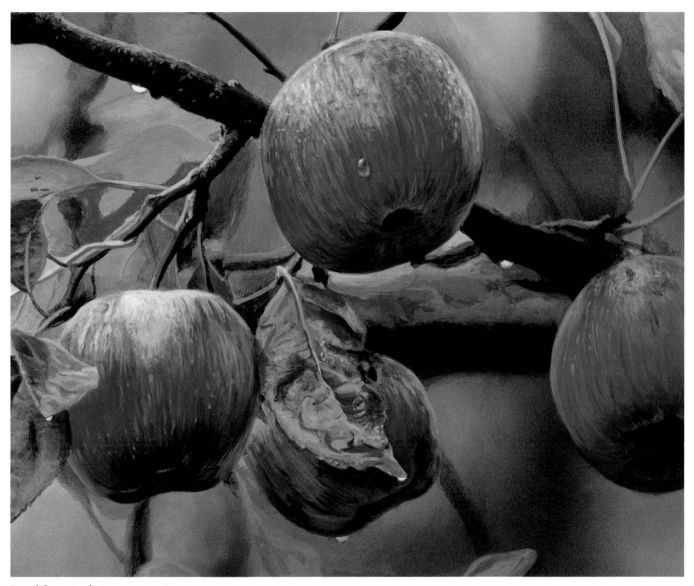

Detail from *Appletime* on page 74.

Rocks and Snow

1 To paint rocks and snow like those shown in *The Summit* on page 18, first draw the outlines. Using Richeson no. 6 and no. 10, series 9050 brushes, block in basic colors. For the rocks I use Burnt Umber, Payne's Gray and Titanium White. For the snow I use Payne's Gray, Ultramarine Blue and Titanium White. I purposely paint the snow darker, planning ahead to paint lighter values on top.

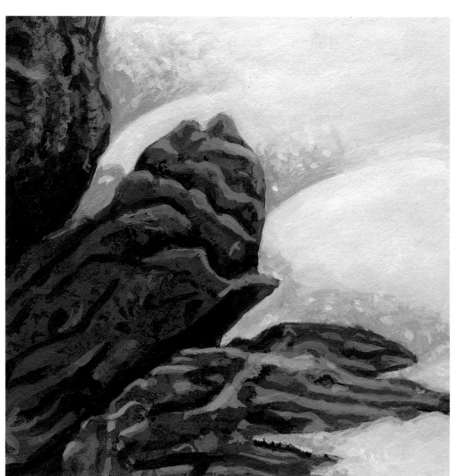

3 Glaze, refine and detail. Paint in the light values on the snow. Additional colors used for finishing are Raw Umber, Burnt Sienna, Raw Sienna and Chromium Oxide Green, applied with Richeson no. 4, series 9000 and no. 6, series 9050 brushes.

2 Block in the lights and darks onto the base color. Use a natural sponge to create rock texture with a mix of Payne's Gray and Burnt Umber. The brush work is done with a Richeson no. 6, series 9050 brush, using the same colors listed in step one.

Detail from *The Summit* on page 18.

Special Effects

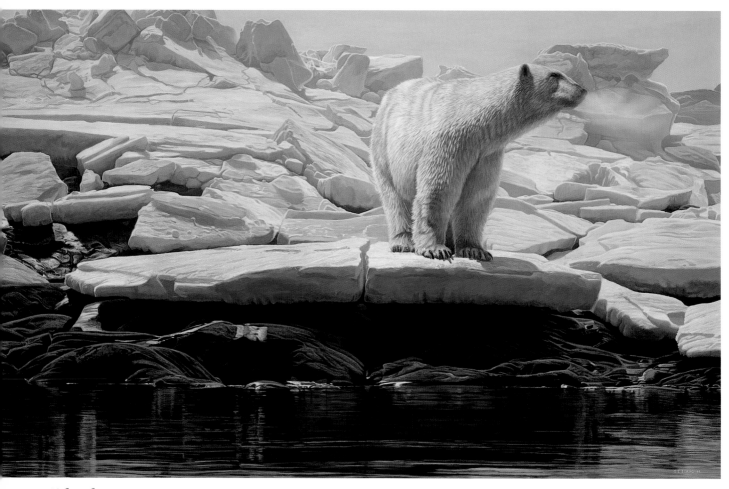

CUMBERLAND SOUND
24" × 40" (61cm × 101.6cm)

Airbrush

To achieve special effects I sometimes use an airbrush. The one I use is an Iwata dual-action model HP-C. I use a compressor for the air supply. In the painting *Cumberland Sound* I used the airbrush to create the condensation of the polar bear's breath in the cold arctic air. I also use an airbrush to mist, add atmosphere and unify the various parts of a painting.

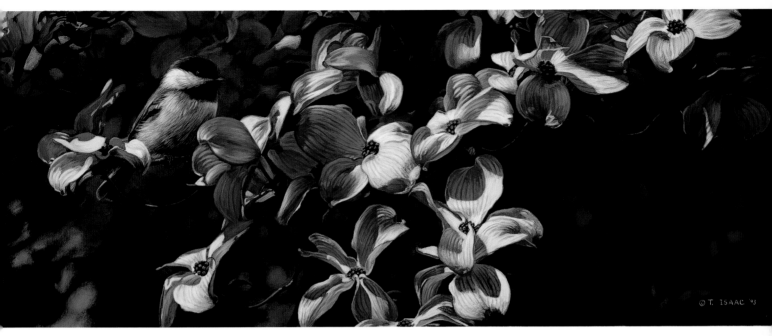

Scumbling

Don't throw away those frayed, worn-out brushes. Oftentimes they are perfect to create soft edges in the background of a painting. To create this soft look, wipe excess paint and moisture from the brush with a rag, then scrub on the paint in the appropriate areas, using a scrubbing or scumbling technique. In *Spring Celebration* you can see how I used this technique in the background areas.

SPRING CELEBRATION
3⅜″ × 9⅛″ (8.6cm × 23.2cm)

Tips on Painting Feathers

The plumage of many birds differs between juveniles and adults and between males and females. Plumage can also vary by geographic location and environment. Flight feathers on wings are stiff and have a hard finish. Covert, breast and facial feathers are smaller and softer. Feathers are modulated, as is the entire wing, so look at the whole as well as the pieces. Feathers are somewhat like shingles on a roof: Generally speaking, just the tips of the feathers are exposed, with the upper feathers overlapping those below.

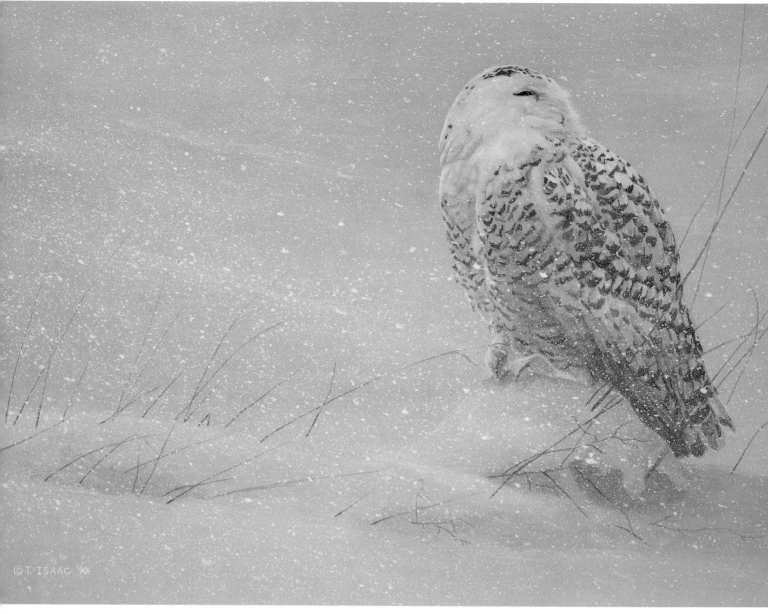

Toothbrush

Another tool I use on occasion is a toothbrush. I sometimes use it and a natural sponge to create a porouslike texture on rocks, moss, snow, tree bark, etc. One of my favorite uses for the toothbrush is to create blowing snow. This snowy owl painting is a good example of the end result. Practice flicking random specks of paint from the bristles of the toothbrush on a scrap of paper before attempting this technique on your painting. It's a good idea to lay newspaper around the painting—this process can be messy, but is also fun!

SNOWY OWL STUDY
8½″ × 11⅞″ (21.6cm × 30.2cm)

Gallery of Textures

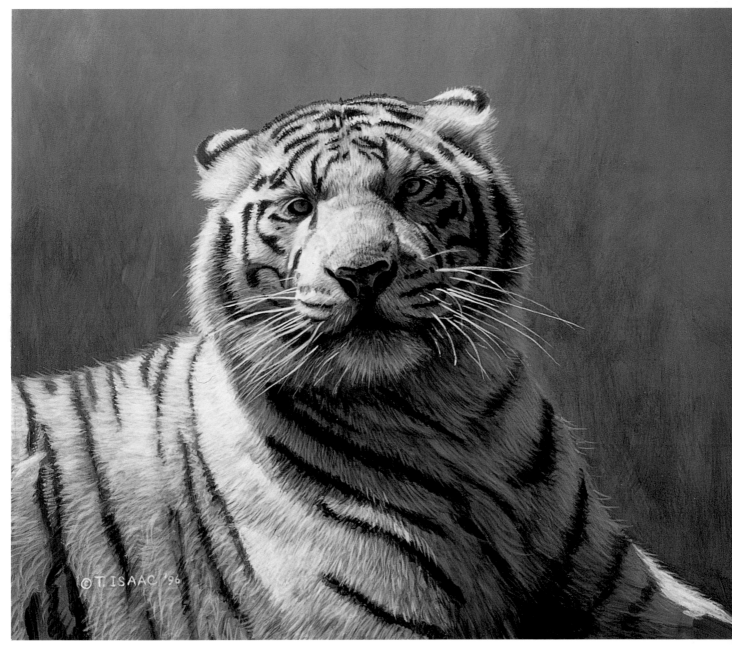

WHITE TIGER
6⅞" × 7⅞" (17.5cm × 20cm)

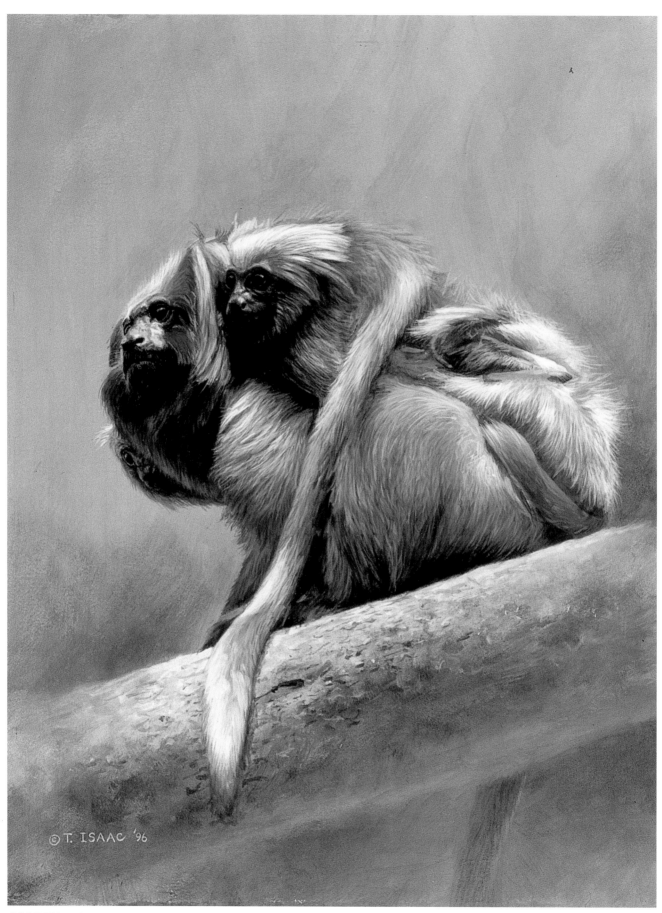

GOLDEN LION TAMARINS
18″ × 8″ (45.7cm × 20.3cm)

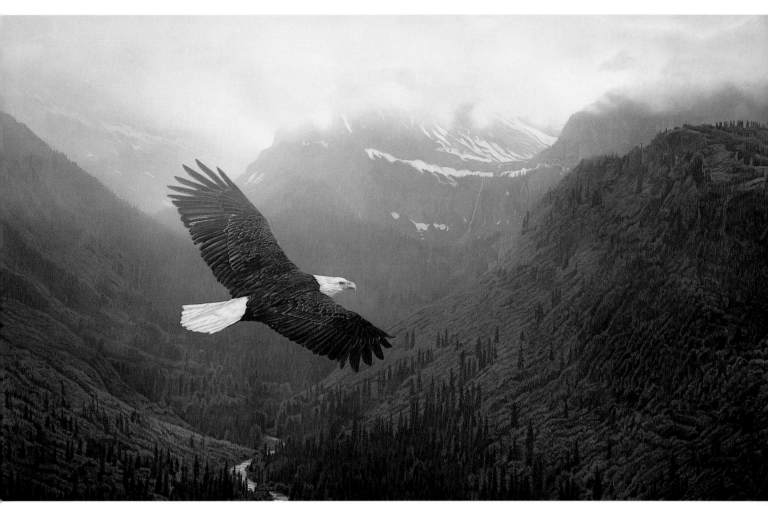

INTO THE MIST—BALD EAGLE
23¼″×40″ (59.1cm×101.6cm)

Integrating the Subject With the Scene

It is often necessary to use an animal or bird from a different reference photo than the one for the setting or habitat you want to place it in. For example, you might want to combine the bird from a photo of your backyard bird feeder with a reference photo of a rustic farm fence. This chapter will help you combine references and make it look natural.

OUT OF THE ICE AND SNOW
36" × 21" (91.4cm × 53.3cm)

Choosing the Correct Habitat and Scale

There are several things to consider when unifying subject and scene. One of the first is what is the correct habitat for the species being depicted. Researching your subject is a must. Seasonal aspects must be considered—the subject's look must correspond to the appropriate time or season shown in the setting.

Second, you must be sure the size of the subject is to scale with the setting. Often when I am doing a bird and flower painting, I will measure the actual blossoms and use a field guide to look up the bird's size so I can show accurate proportions.

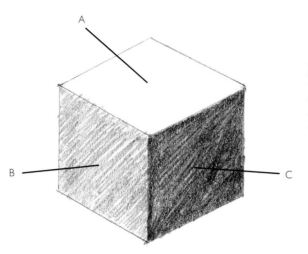

If this cube represents one of the objects in your painting, any other object on the same plane as *A* will be close to this lightest value and tone. Any object on the same plane as *B* will be close to this middle value and tone, and so on.

Lighting

When combining a variety of references, the third thing to consider is that there should be a single primary light source. It is important to have the same quality of lighting and atmosphere on both the subject and the setting. All planes of the same angle will be roughly the same tone. Reflective light and cast shadows will also have an impact.

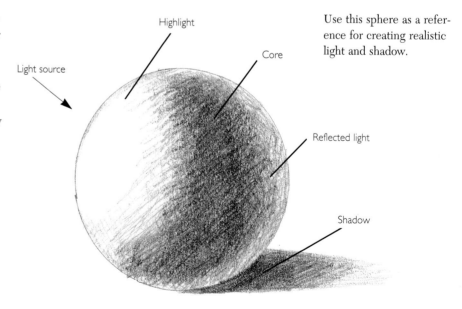

Use this sphere as a reference for creating realistic light and shadow.

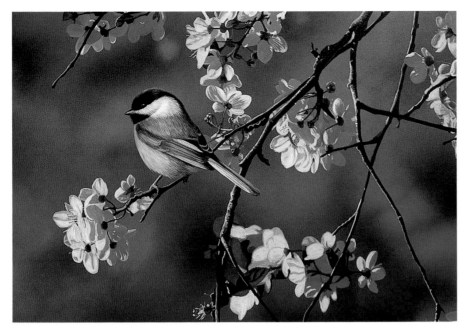

Creating consistent lighting with subject and setting can be an ongoing struggle. While painting *Chickadee and Plum Blossoms*, I felt in need of a fellow artist's critique. My consultation helped me realize that the lighting wasn't quite consistent. In this original study I had painted the chickadee lit from the front. What I needed was a backlight/sidelight coming from the left. Many times, another opinion helps!

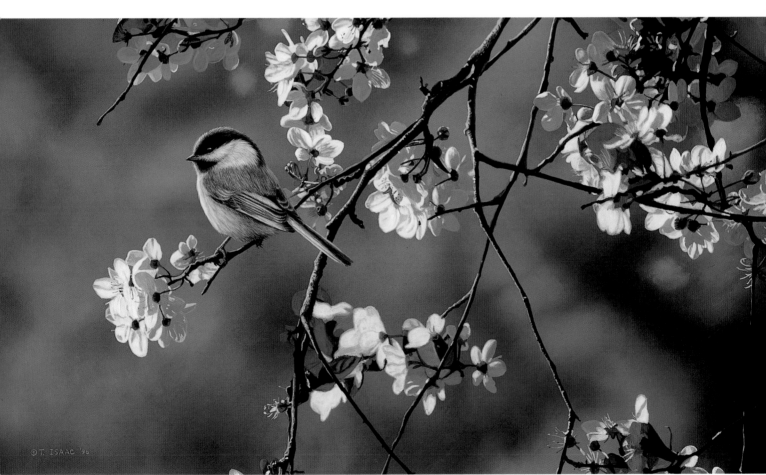

CHICKADEE AND PLUM BLOSSOMS
9″ × 16¼″ (22.9cm × 41.3cm)

Sometimes it is necessary to change the lighting in your subject reference to integrate with the lighting in the scene. *Spring Song* presented just such a challenge. What made this process easier was finding a reference of a different bird (bottom photo) that had the lighting I was after. I used that reference as a guide for lighting the birds I was painting. Occasionally it may be necessary to make a clay model of your subject and light it according to the light you want in your painting. This model can help you understand how the light falls on the planes of the subject under the desired lighting conditions of your setting.

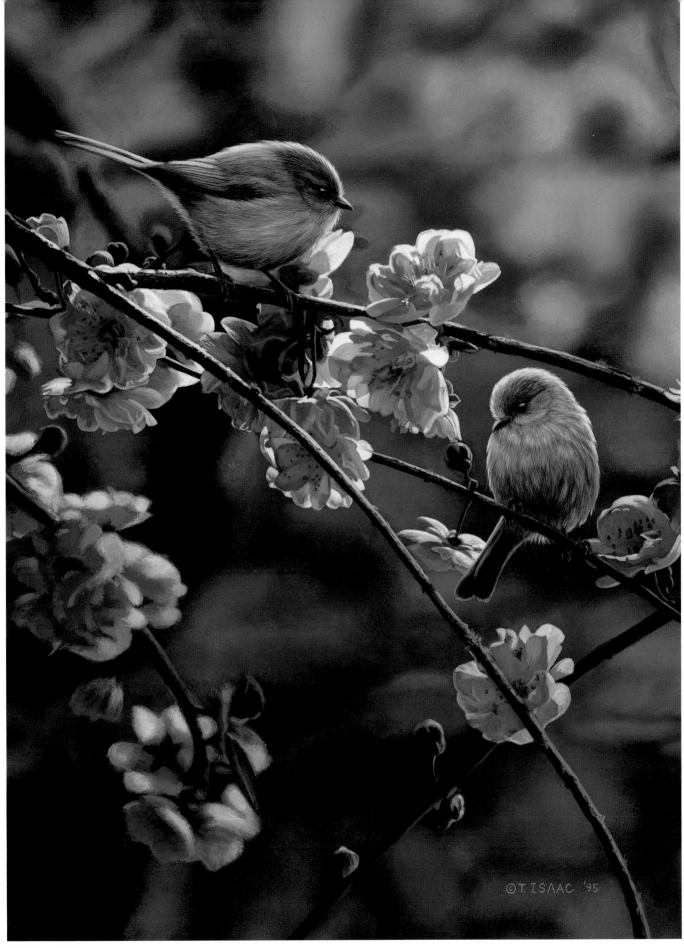

SPRING SONG
12″×9″ (30.5cm×22.9cm)

This painting was inspired by the behavior of the young cats. They are a brother-sister pair I observed at a zoo. They had chased each other for quite some time and had finally worn themselves out. One lay down and the other followed, putting its paw over its sibling's back. It was a magical moment I had to paint. I used several references in combination to create the final painting. In order for the cougars to seem integrated with the scene, lighting had to be consistent. Often when I paint an animal or bird in a scene, I will paint something in the environment to overlap it. This helps a lot to make the subject look like it fits into the scene. In this case I painted the golden grasses overlapping the cougars to achieve this effect.

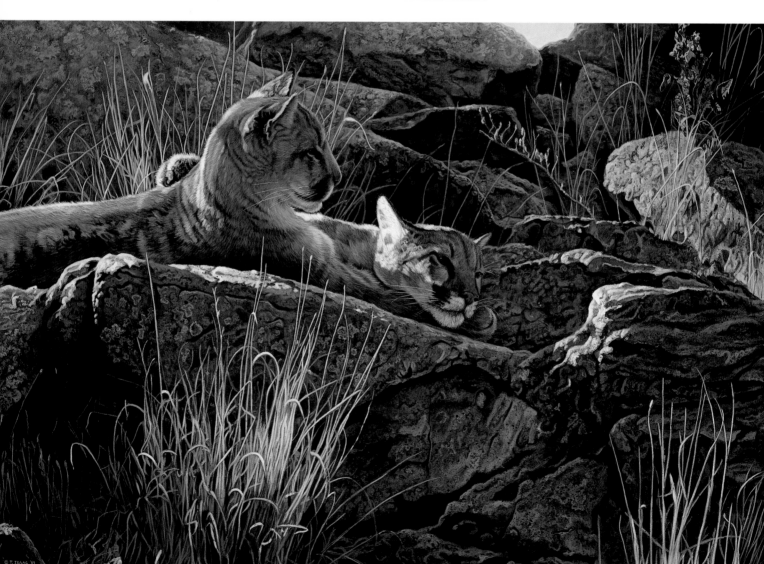

AFTERNOON LIGHT—YOUNG COUGARS
20″×30″ (50.8cm×76.2cm)

Overlapping the Subject

It's a good idea to have objects overlapping the main subject to avoid it looking cut out and glued on. Figure grounding is also essential. This refers to "losing" the edge of the subject into the background. Overlap is also a key ingredient to achieving the illusion of depth. That's why it's best to paint what is farthest away from the viewer first and finish with what is closest.

When painting a scene that has both light and shadow, the inclination is to paint the main subject in the light. In *Spring Shadows* I chose to paint the cottontail rabbit in the shadows. Keeping light subdued on the rabbit—and brightening and overlapping the foreground vegetation—help convince the viewer that the cottontail really is a part of the scene and not cut out and glued on top of the painting.

SPRING SHADOWS—COTTONTAIL
18″×6¾″ (45.7cm×17.2cm)

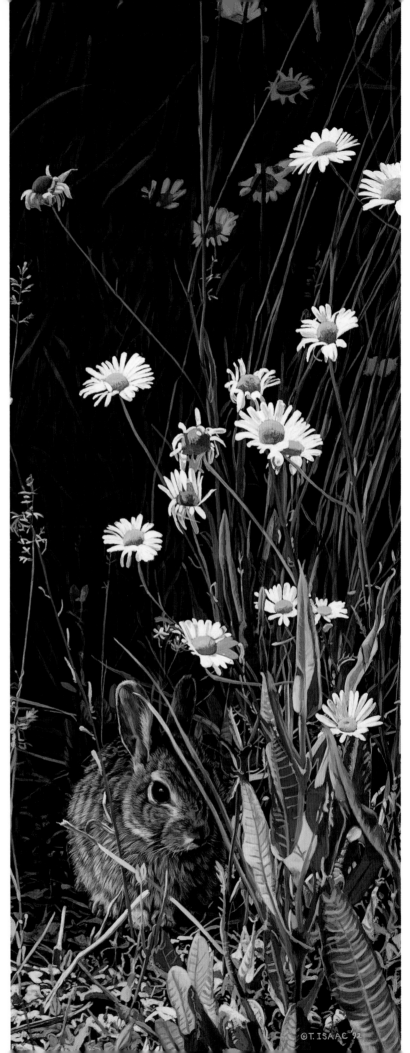

Creating Depth

Many devices can be used to create the illusion of depth in a two-dimensional painting. The most obvious of these is the use of perspective—objects become smaller as they recede in space. Accordingly, feathers, fur and other textures, such as bark, compress as they go around a form. Painting a shape such as a river larger at the bottom of the painting, then progressively smaller as the river enters into the painting creates depth and moves the viewer's eye into and through the painting. Vertical placement also helps create a feeling of depth: Objects placed lower in the picture plane will appear closer; objects placed higher will appear farther away from the viewer.

Aerial perspective is employed when, as the viewer's eye looks toward the horizon, the atmosphere becomes hazy because of particles in the air. I create this look of depth in a painting by minimizing contrast, toning or graying the hues in the background and gradually increasing the contrast and color saturation in the foreground. Higher contrast and bright color tend to advance in space while minimal contrast and dull color recede.

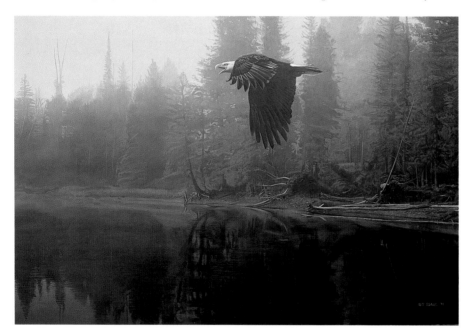

Compare the eagle in this study to the finished painting below. In the final painting I've added more mist on the eagle and lightened the value on its back and wing that are farthest from the viewer. The eagle looks more a part of the scene with the change.

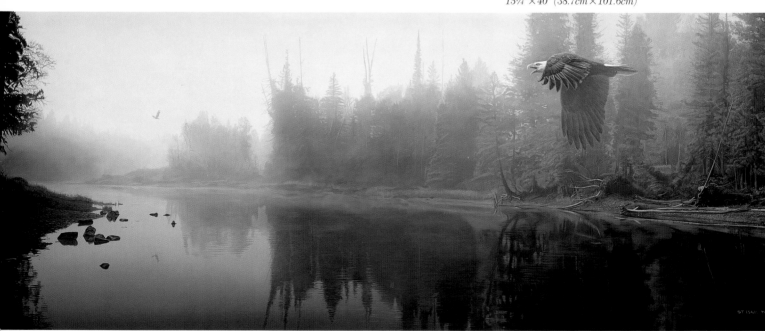

CALL OF AUTUMN
15¼" × 40" (38.7cm × 101.6cm)

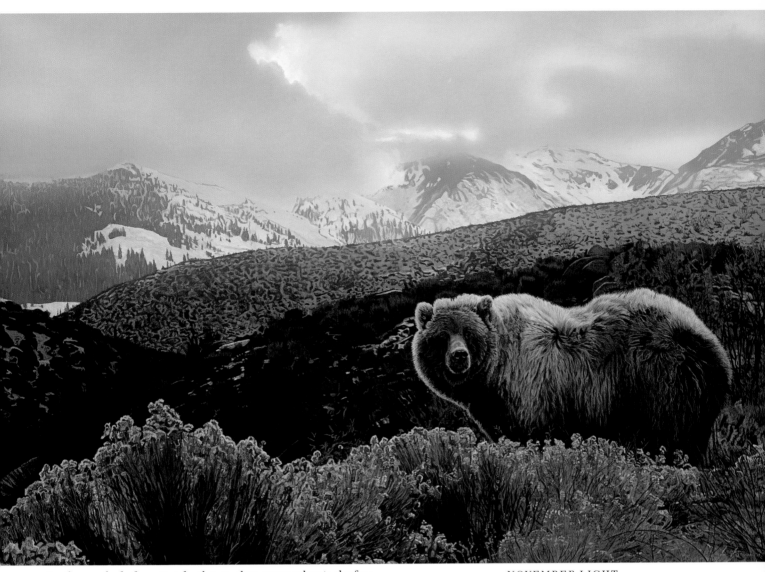

Another method of creating depth is to place warm colors in the foreground and cool colors in the background. *November Light* is a good example of this. Be aware of the thermal qualities of color when trying to create depth in a painting.

NOVEMBER LIGHT
24″×36″ (61cm×91.4cm)

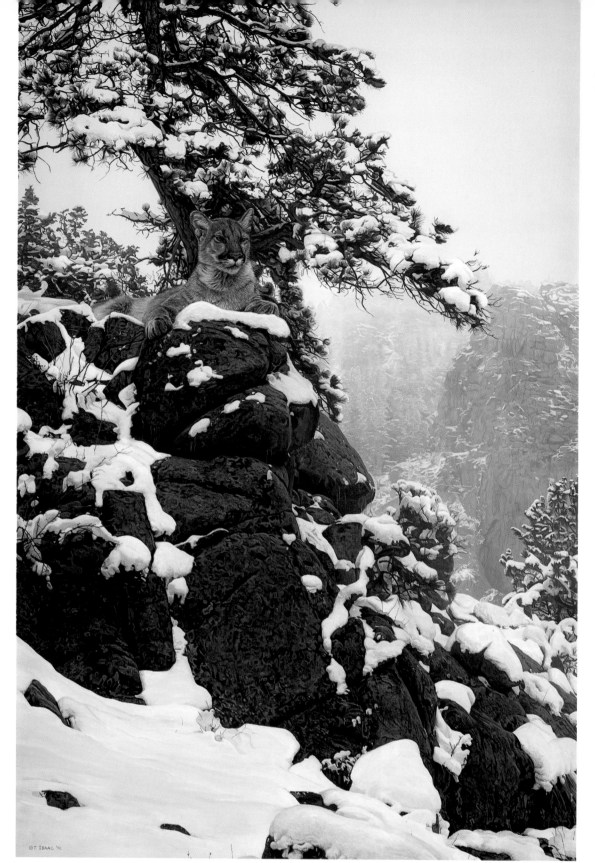

In *Snow Spirit* you can see how the manipulation of color and contrast creates the illusion of depth. My values and colors are much stronger in the foreground and fade as they recede into the background. This is what aerial or atmospheric perspective is about. In reality, what creates this is a body of air between an object or scene and the viewer. The greater the distance between object and viewer, the more the softening of outlines, blurring and cooling of colors, with less and less detail.

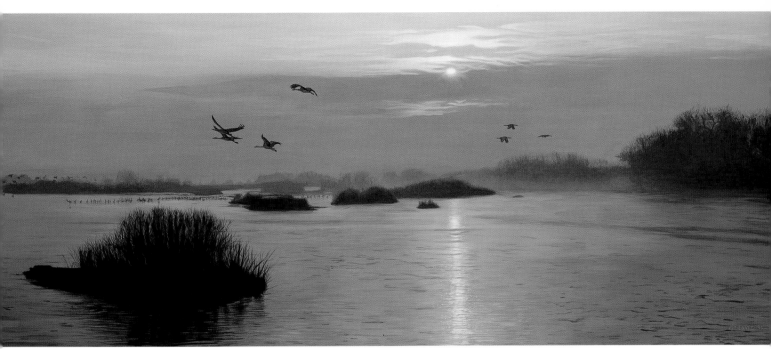

In *River of Gold* you can see how I used many devices to achieve a feeling of depth. The river depicted is the Platte in Nebraska. There are many small islands in the particular area I painted. I used contrast, size and vertical placement to create depth in this painting. As the islands in the river went back in illusory space, I made them progressively lighter and smaller and placed them closer to the horizon line.

RIVER OF GOLD
12" × 30" (30.5cm × 76.2cm)

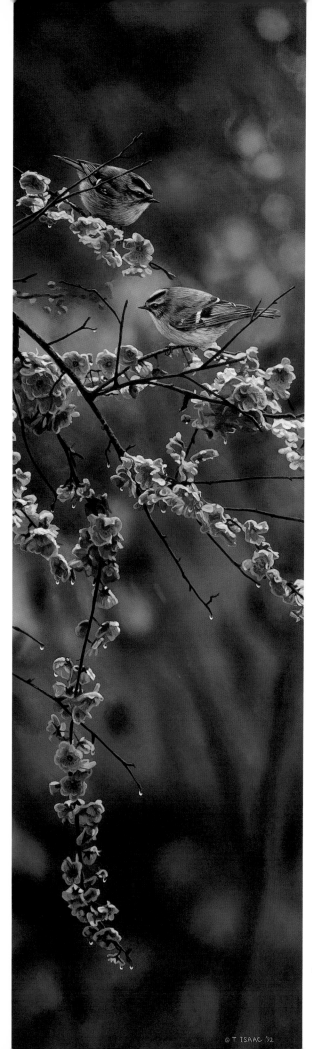

Creating soft edges in the background and hard edges in the foreground will also help create the sense of depth. In these two paintings the backgrounds are out of focus, and background objects have soft edges.

BLOSSOM DANCE
23¼″ × 6¾″ (59.1cm × 17.2cm)

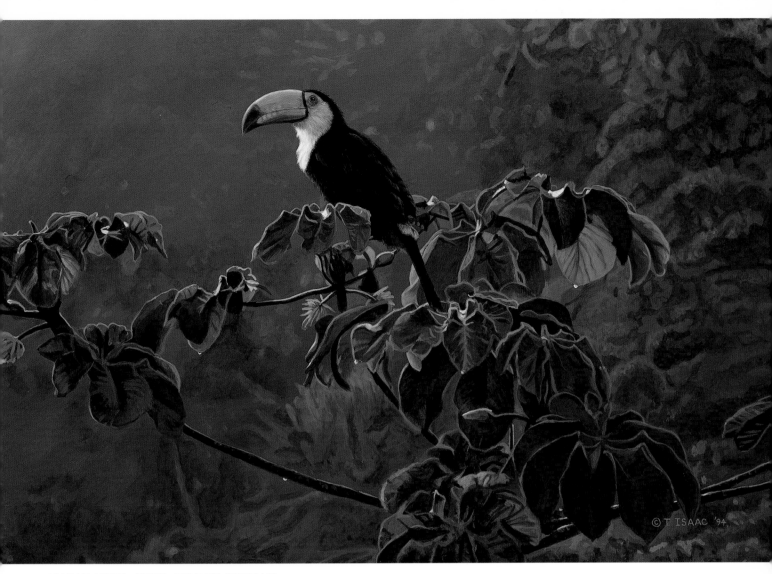

MAYAN MIST—KEEL-BILLED TOUCAN
9¼″ × 21½″ (23.5cm × 54.6cm)

Repeating Color

It is also a good idea to repeat the color of the subject in the background and the background colors in the subject. Painting bits of ambient color onto the subject helps to eliminate the look of being cut out and glued on.

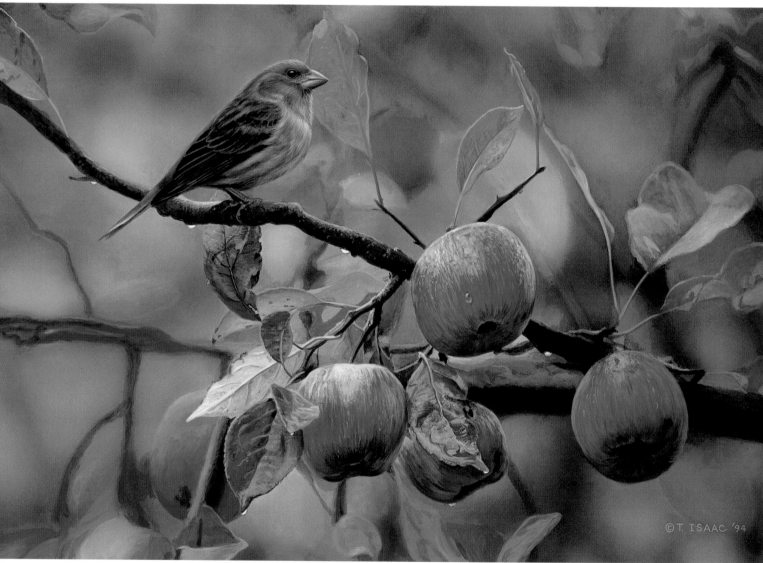

Another aspect to consider when integrating the subject with the scene is repetition of color. In *Apple Time—Purple Finch* you can see I used the same reds for the apples as are on the finch.

APPLETIME—PURPLE FINCH
9⅜″ × 14″ (23.8cm × 35.6cm)

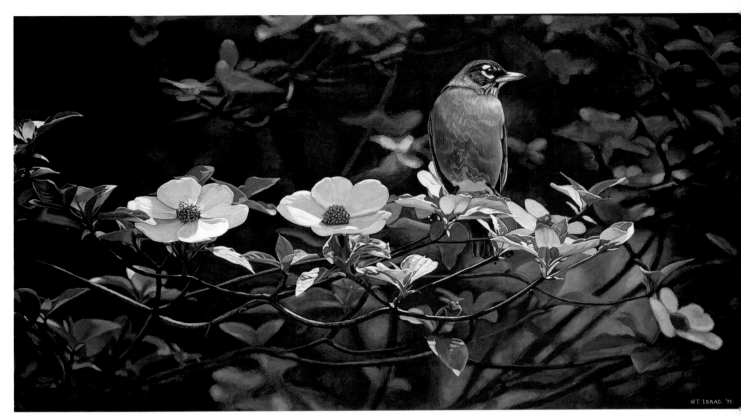

In *Backyard Robin* I combined several references for a single painting—one of a robin and a few of dogwood blossoms. To make the robin look believable in this setting, I reflected the color and light of the adjacent dogwood leaves onto the robin. I also overlapped the robin's feet with leaves to further integrate subject with setting.

BACKYARD ROBIN
12½" × 24" (31.8cm × 61cm)

Getting the Correct Pose

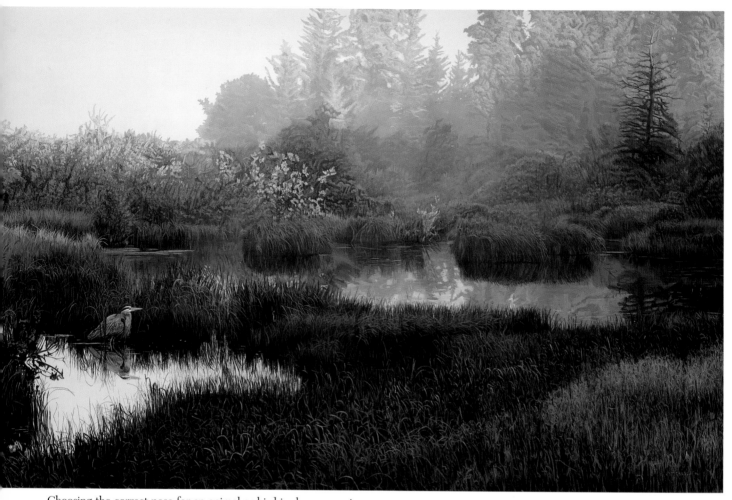

Choosing the correct pose for an animal or bird is also an ongoing challenge. In *Morning Marsh*, after the heron was finished and again after a critique, I decided that the original pose could be improved upon. The lighting didn't seem quite right, so I altered that, too. Here you can see the before and after. In the water where the heron is standing, I added a subtle gradation of value with the darker water toward the bottom.

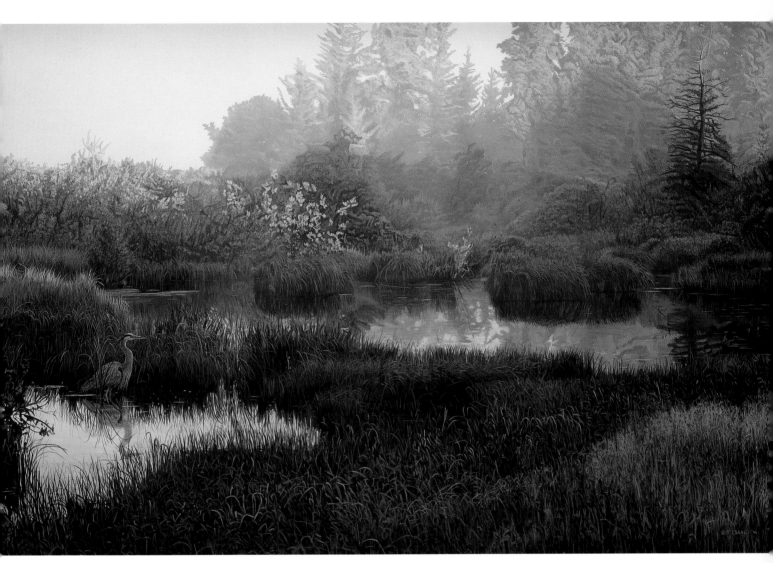

MORNING MARSH
19½″ × 30⅛″ (49.5cm × 76.5cm)

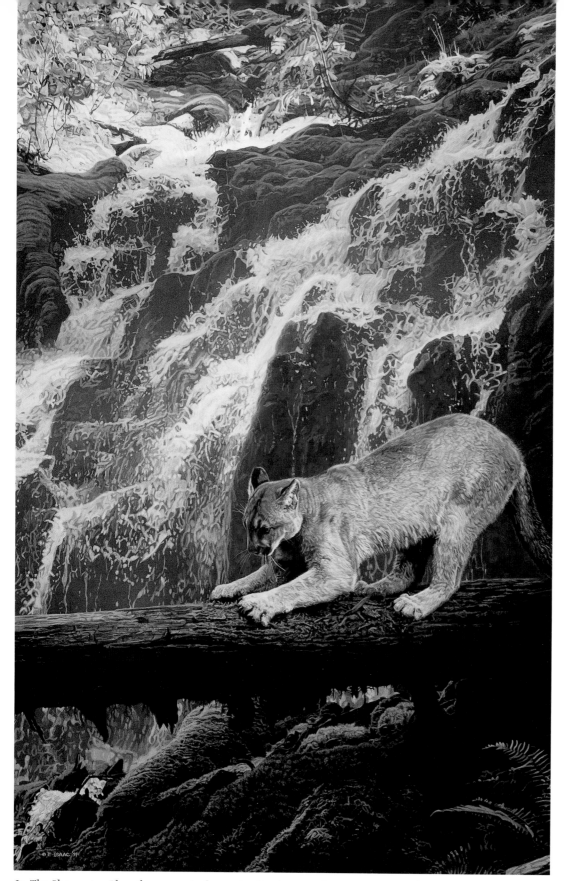

In *The Sharpening Place* the cougar is sharpening his claws, marking territory, on a log over a waterfall. I took the reference photos of the cougar on a misty day. When searching for an appropriate setting reference, I found that if I stood close to the waterfall, it created the same misty effect. To integrate the subject and scene, I also referred to a photo of a cougar with damp fur. Make sure you paint your subjects in a manner consistent with what is happening in the environment or habitat you will be using. Also remember objects that are closer to the viewer will not have the same degree of mist or atmosphere as those that are further back in the picture plane.

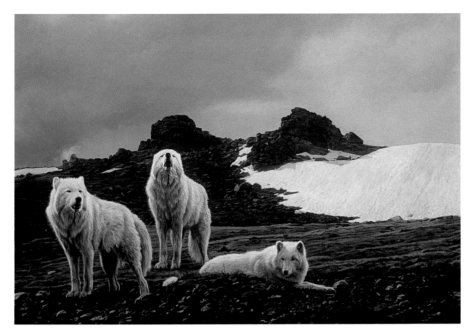

In *Tundra Song*, I first painted a small
12″×18″ (30.5cm×45.7cm) study. I liked the
painting concept, but wanted to make some
changes to the final larger version. In the final
painting I eliminated the middle rock forma-
tion, selected one wolf and made it larger, and
misted back or subdued the background to
create a greater feeling of the vastness of the
Arctic. I also used abstract shapes to lead the
viewer's eye around the painting. For exam-
ple, the larger snow bank on the right of the
painting creates a shape leading to the wolf's
head. The small snowbank on the left acts like
an arrow leading to the wolf. Airbrushing
breath gives the wolf life and ties in with the
atmosphere in the distance.

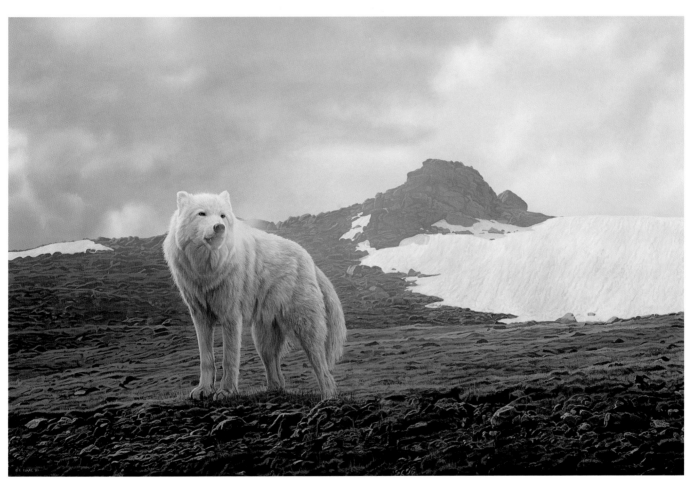

TUNDRA SONG
24″×36″ (61cm×91.4cm)

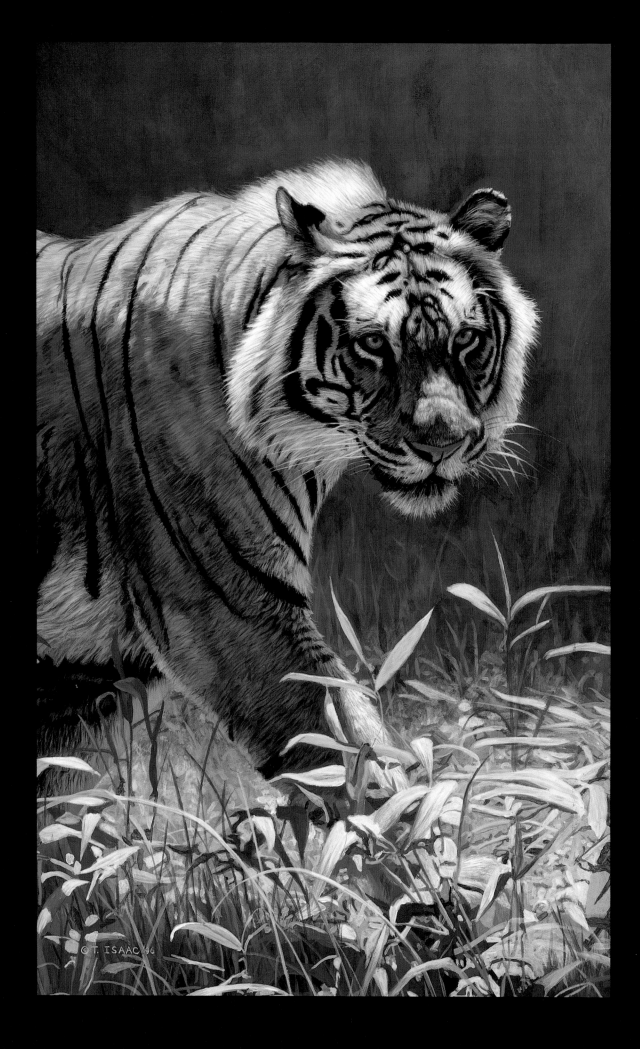
© T. ISAAC '96

Putting It All Together Step by Step

In this chapter I will complete four different paintings. My inspiration and intent are different in each piece. The first painting, *Yosemite Dawn*, is a large panorama where lighting and atmosphere are the essential elements. The second painting, *Springtime Blues*, is a small environment with nearly all the focus on the foreground. The third painting, *After the Storm*, is primarily a seascape at sunset, inspired by the dramatic sky and reflections in the wet sand. The final painting, *Tyger! Tyger!* focuses on the subject. Although the background shows habitat, the animal is large in the format and moving right toward the viewer, creating the feeling that the cat is practically walking out of the painting.

CATWALK—TIGER
13¼″ × 8⅜″ (33.7cm × 21.3cm)

Working From General to Specific

I almost always paint the basic value or color first, then add the detail on top. I paint overall shapes first, then paint the particulars over the top, layering on detail. I nearly always paint from background to foreground, from general to specific.

I have my initial brushstrokes go in the direction of the fur or feathers. The brushstrokes themselves help create texture and detail. If the visual information is too complex, I will isolate or crop in on my subject and paint smaller areas so that the process is not so overwhelming. For example, when painting a bird, I might mask out everything but its beak with pieces of paper, so that I can really focus on just that area on my reference and on my painting.

Making It Work

Often I use a mirror to view my paintings. This helps to see the painting in a new and fresh way and helps to find trouble spots. I also turn my paintings upside down to see if depth is being created properly. Taking paintings into rooms other than your studio or into other lighting conditions can also help. If the painting is working, it should work just as well in other contexts.

Artists should be ruthless about fixing mistakes. Don't be afraid to change something that is not working. I have been known to cut off part of my painting with a saw if I felt it would strengthen the design.

Keep in mind that the habitat and animal or bird shouldn't compete for attention. Play up one or the other. Subdue and lessen the contrast in areas in your painting that may distract from the main subject.

When painting an animal or bird, don't be a slave to the color as you know it to be. Change it to make it more real. Add environmental colors, reflective color and light.

It's also important to avoid the "cookie cutter" look. Everything is unique and has a specific look or orientation in space. Don't just stamp out the same leaf shape over and over in a plant or tree, for example.

Strive to avoid contrived designs. Try to create something that looks new and fresh, that you haven't seen a million times before.

GOLD ON THE ROSE—
AMERICAN GOLDFINCH
18"×24" (45.7cm×61cm)

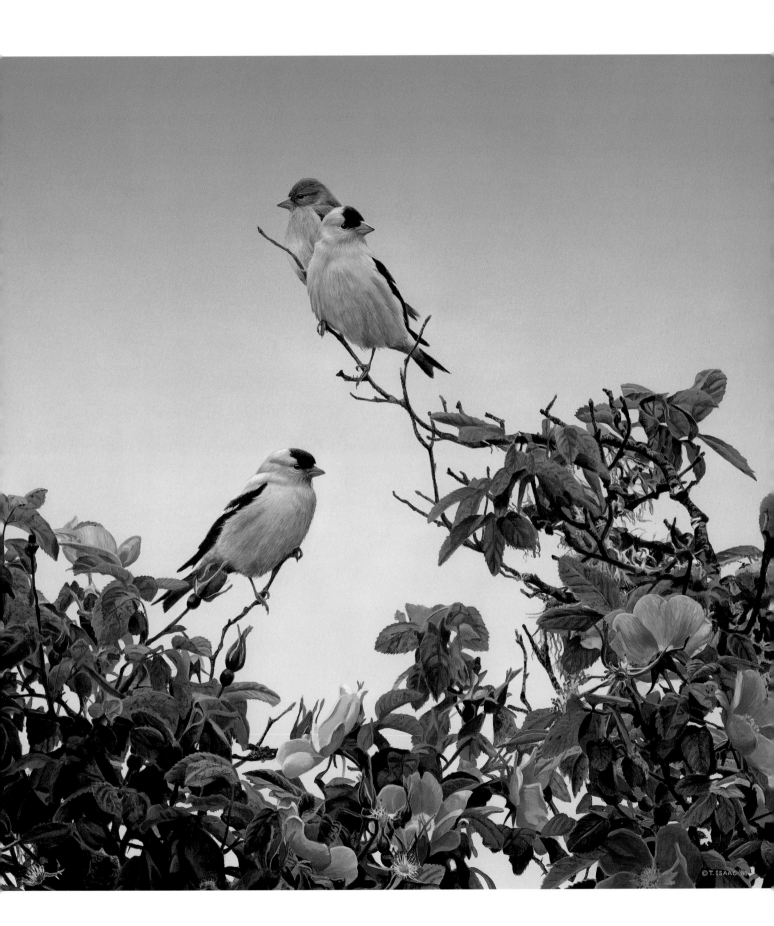

Yosemite Dawn

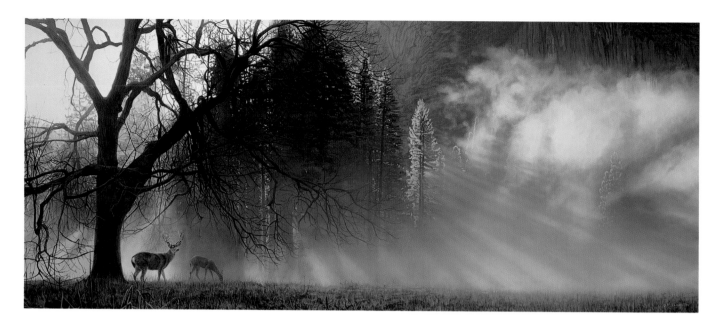

Fieldwork

The first step in beginning any painting is fieldwork. I took a winter reference trip to Yosemite National Park. Although it was bleak and rainy the first few days I was there, on the third morning the sun came out, mist rose from the rain-soaked meadow and sunbeams filtered through the trees. The mist created an ethereal effect that made me feel as if I were in another world. I took many, many pictures.

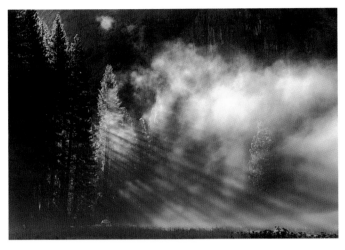

Supplies

- Untempered Masonite board
- White gesso
- Liquitex acrylic paint

 Payne's Gray
 Raw Umber
 Titanium White
 Unbleached Titanium White
 Raw Sienna
 Ultramarine Blue
 Permanent Hooker's Green Hue
 Burnt Umber
 Neutral Gray Value no. 5
 Chromium Oxide Green
 Yellow Oxide
 Dioxazine Purple

- Richeson no. 10 flat, series 9050 brush
- Richeson no. 10 flat, series 9050 brush, slightly frayed
- Richeson no. 4, series 9000 brush
- Richeson no. 1, series 9000 brush
- Low-tack tape
- Airbrush
- Gloss medium

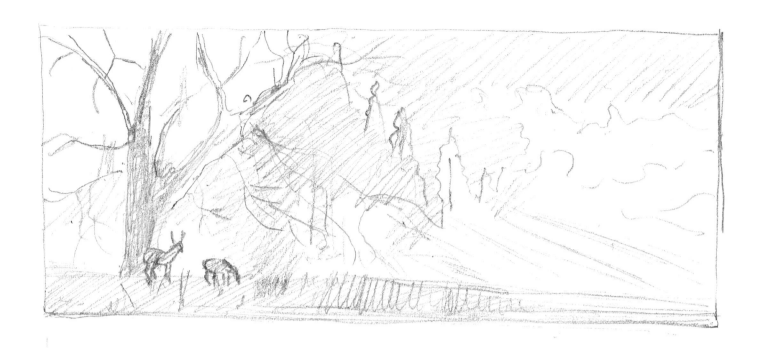

Thumbnail Sketches

Back in my studio, I drew thumbnail sketches of the basic composition and idea. Though the deer were not in the scene when I photographed it, I had seen many in the area and thought they would make a good subject for a meadow scene. I actually used a buck for the doe reference, removing the antlers and slimming down the body mass. After deciding on the two deer poses, I still wasn't sure if I should place the buck overlapping the tree or to the side of it. After some deliberation, I decided to paint it to the side so the shape would read more clearly as a silhouette.

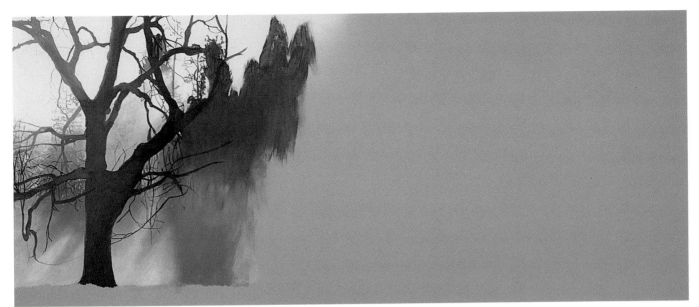

1 To begin the painting, I prime the untempered Masonite board with white gesso to which I have added Payne's Gray and Raw Umber. I first paint the upper left corner with a mixture of Titanium White and Unbleached Titanium White, using a Richeson no. 10 series 9050 flat brush. I then airbrush the area with the same mixture to minimize streaking. Next, I begin to block in the tree and background in the upper left corner, using Payne's Gray, Raw Sienna, Unbleached Titanium White, Ultramarine Blue, Raw Umber, Burnt Umber, Neu-tral Gray Value no. 5, Chromium Oxide Green and Yellow Oxide. Using a technique called *scumbling*—applying a thin coat of opaque color in a rubbing or blurring manner to create soft edges—I begin to block in the misty background using a Richeson no. 10, series 9050 flat brush that is a bit frayed and worn. The predominant colors in the background are Titanium White, Payne's Gray, Ultramarine Blue, Raw Umber, Unbleached Titanium White, Raw Sienna and Neutral Gray Value no. 5.

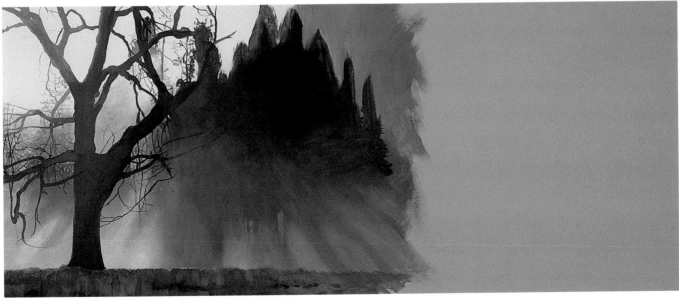

2 In this step, I continue painting the larger mass of distant trees in the middle of the painting. I also block in shafts of light coming through the bottom area of trees and begin to block in the grassy area on the bottom of the painting. The grass area at this stage is composed of vertical brushstrokes with a paint mixture of Raw Sienna, Burnt Umber, Raw Umber and Payne's Gray.

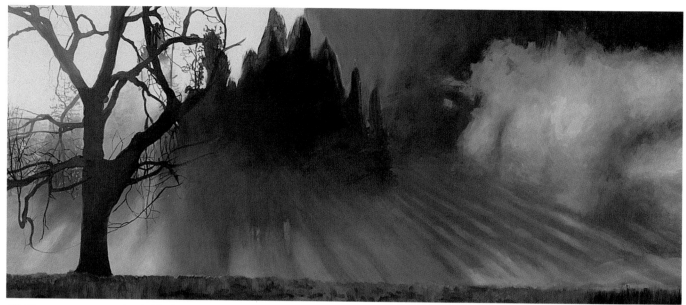

3 The painting is completely blocked in but quite rough at this stage, lacking in detail and refinement. This is where I begin to build detail onto the basic structure.

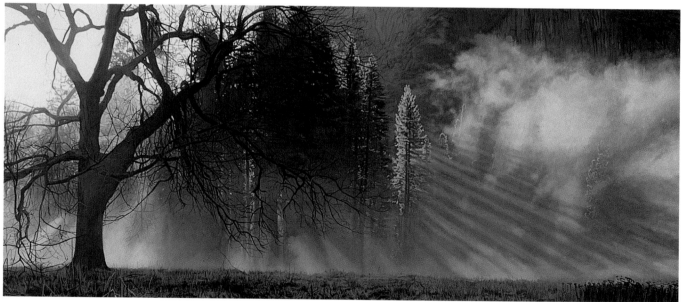

4 Now I add lighting and some detail in the background middle trees. I also paint the branches on the big tree that overlap the background trees and add more detail to the grass area on the bottom of the painting. At this stage, the brushes I use are Richeson no. 4, series 9000 and no. 1, series 9000 for creating detail. The paint colors I use are the same used for the initial blocking in.

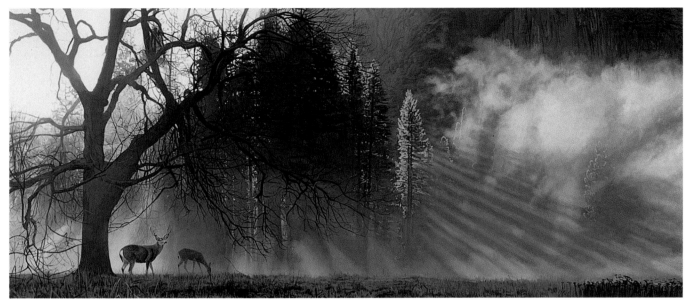

5 I continue to refine the background and block in the deer. I paint the deer with Raw Umber, Burnt Umber, Titanium White, Payne's Gray and Raw Sienna.

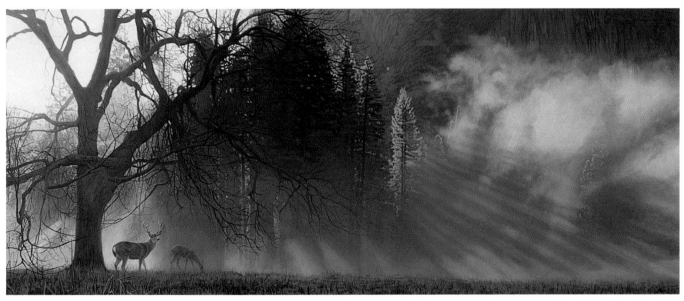

6 At this stage I decide to remove the dark plants on the bottom right of the painting and paint this area similar to the adjacent area. It is always important to edit your references and not be a slave to them. I also begin to refine the deer with fur detail and to model the planes of the bodies. In addition, I use an airbrush with a mixture of Titanium White and Unbleached Titanium White to soften the shafts of light and a mixture of Payne's Gray and Titanium White for the bluish-gray area at the base of the trees to create more of a feeling of mist and atmosphere.

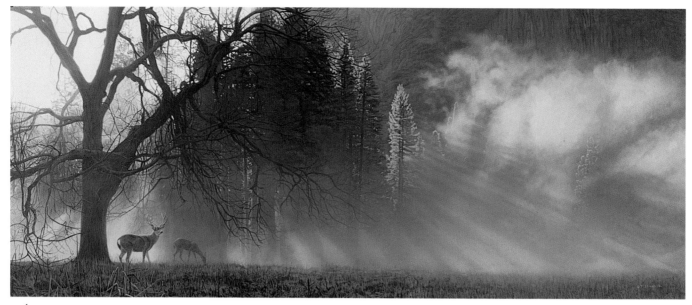

7 Here I rework the light beams and soften them. Even though the photo reference shows defined lines of light, they look too striped and also a bit too busy. I lighten the rock face behind the tree to add to the illusion of depth. I add bits of arbitrary color (Dioxazine Purple) to the outlines of the deer and tree. I continue to add detail and refine the pictorial elements until the painting seems complete with all areas resolved. Finally I sign my name and date. It has taken six weeks to complete the painting.

Is it Finished?

When I complete a painting, I usually have several people view it, asking them if there is anything that bothers them or they would like to see changed. I also look at the painting with a mirror to see the image reversed. This allows me to see the painting in a new way and helps me to spot any problem areas.

To judge if the painting is finished, I ask myself several questions. Does the painting seem resolved? Does the animal or bird seem unified with the background? Is the viewer's eye going where I want it to go? Is there anything distracting? Does the painting have convincing depth and lighting? Does the painting seem fresh?

If there is anything that bothers me, I change it. I strongly believe that all of my paintings can be improved. I strive to get a painting to the point where I am comfortable with it and then move on. Sometimes it's helpful to put a painting away for a while, begin another painting and then return to the first.

The last step in the painting is placing a finish on top to protect it. During this process I use low-tack tape over the entire surface to remove any dust, then I airbrush several coats of gloss medium (mixed with water) allowing the painting to dry between coats. I am careful not to overspray. If too much is applied, an orange-peel texture will result. Before I send a painting away for a show or exhibit, I check the craftsmanship. I look for hairs or spots that shouldn't be there, anything that might distract from the image.

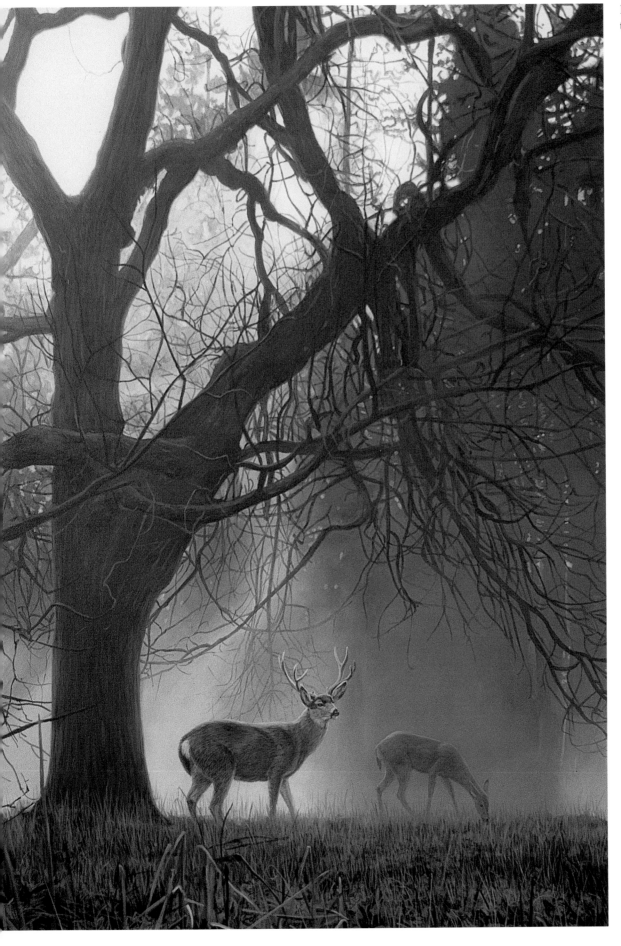

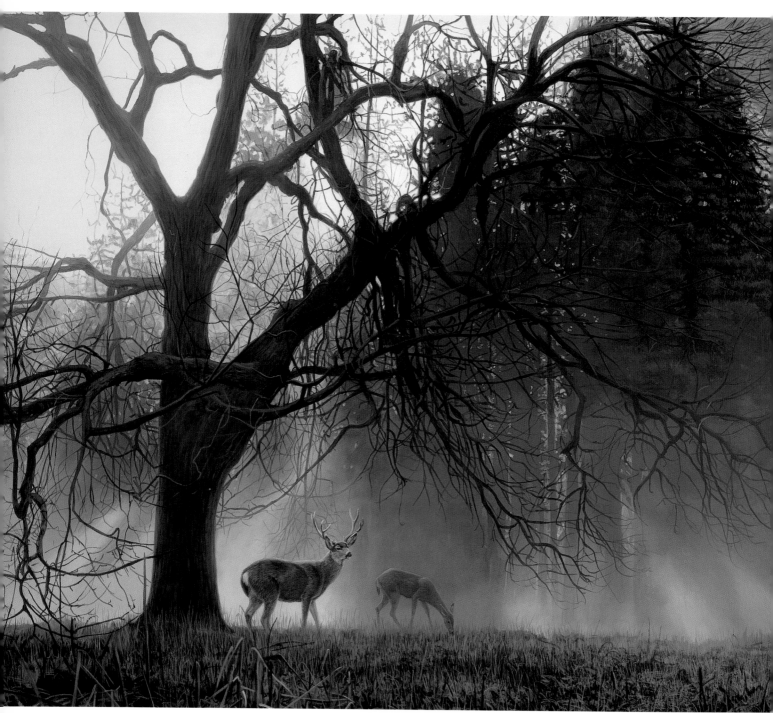

YOSEMITE DAWN
15¼″ × 36″ (38.7cm × 91.4cm)

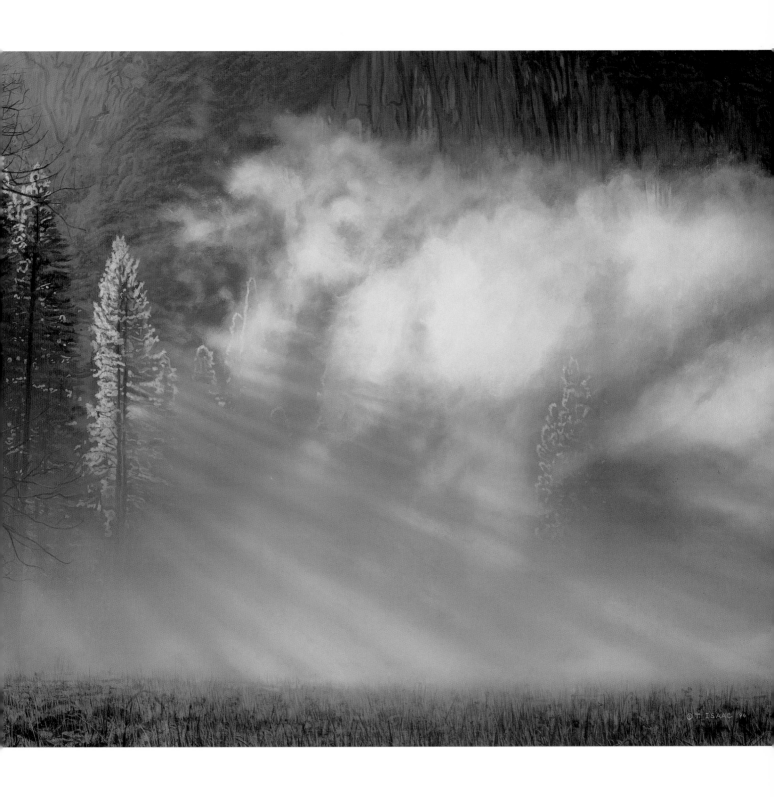

Springtime Blues

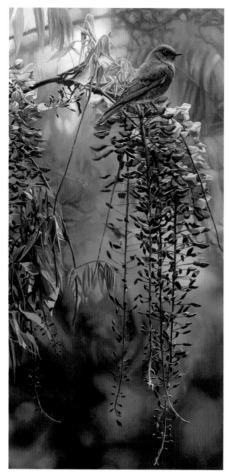

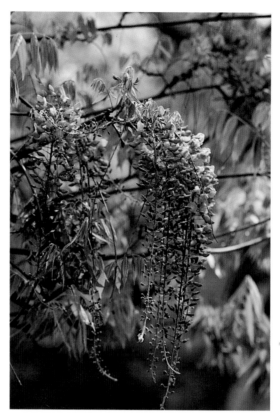

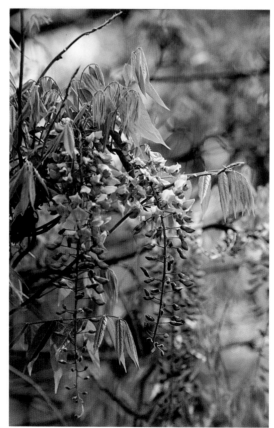

Reference Photos

I must give credit where credit is due: My wife Connie suggested this concept some time ago. She worked at our local community art center and admired the blooming wisteria on the grounds every spring. She thought it would make a great setting for a songbird painting, and I agreed. I took several photographs of the wisteria and dug out some of my photos of bluebirds, thinking that the blues of the flowers and the bird would complement each other.

Supplies

- Untempered Masonite board
- White gesso
- Liquitex acrylic paint

 Dioxazine Purple
 Payne's Gray
 Raw Sienna
 Burnt Umber
 Raw Umber
 Turner's Yellow
 Chromium Oxide Green
 Titanium White
 Permanent Hooker's Green Hue
 ACRA Violet (Quinacridone
 Violet)
 Ultramarine Blue
 Cobalt Blue
 Burnt Sienna

- ½-inch (38mm) brush
- Loew-Cornell no. 10, series 7500
 filbert brush
- Richeson no. 6, series 9050 brush
- Richeson no. 4, series 9000 round
 brush
- Richeson no. 10, series 9050 brush
- Tracing paper
- White graphite paper
- Low-tack tape
- Airbrush
- Gloss medium

Thumbnail Sketches

I choose a vertical format because it best defines the manner in which the vines and small flowers cascade down and sway in the breeze. I make several thumbnail sketches in order to arrive at the basic composition before I begin the actual painting. To get the bluebird in proportion to the vine and blossoms, I measure the length of the vine and paint the bird to correspond to life-size.

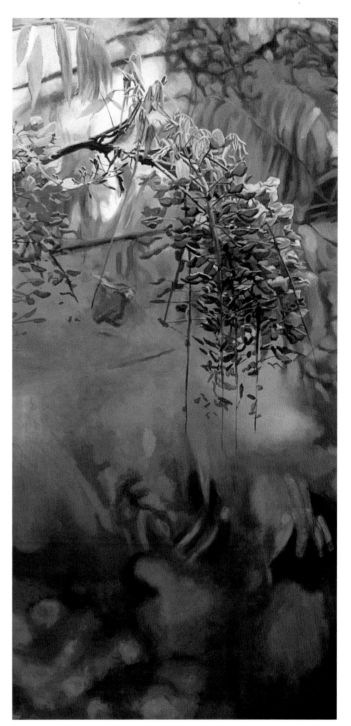

1 After I prime the Masonite board, I start blocking in large areas
 of basic colors with a 1½-inch (38mm) brush. My palette at this
point is Dioxazine Purple, Payne's Gray, Raw Sienna, Burnt Umber,
Raw Umber, Turner's Yellow, Chromium Oxide Green, Titanium
White and Permanent Hooker's Green Hue. For the smaller strokes
I use a Loew-Cornell no. 10, series 7500 filbert and the Richeson no.
6, series 9050 brush. I block in the background of the scene rather
roughly without regard to detail. At this point the painting is quite
abstract. Much of the background is out of focus, so I use a combina-
tion of wet-on-wet and scumbling to achieve softer edges.

2 Next I begin blocking in the foreground branches and blossoms.
 I use the same colors I used in the background, with the addition
of ACRA Violet (Quinacrilone Violet) to the Dioxazine Purple for the
blossom color. Blossoms are painted mainly with Dioxazine Purple,
Titanium White, Ultramarine Blue, Payne's Gray and ACRA Violet
(Quinacrilone Violet). For more control and harder edges, I switch
to a Richeson no. 4, series 9000 round brush. I continue to resolve
the background, making the painting more refined as I layer the
paint. My paint application is quite smooth. I avoid the look of heavy,
thick paint.

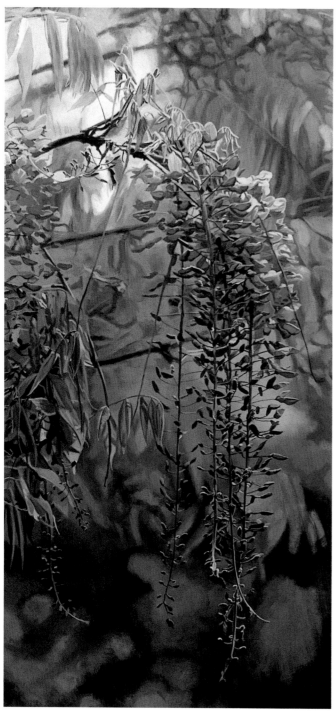

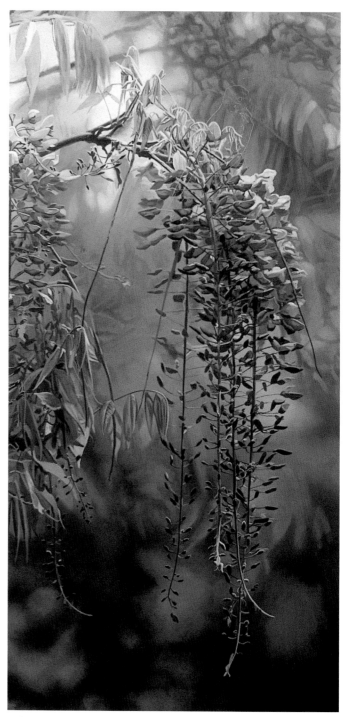

3 Now I have completed blocking in the vines and blossoms. They are still a bit rough at this point and will need future refining.

4 The background is too busy, so I eliminate two horizontal branches that tend to stop the vertical flow of the composition. They aren't necessary and distract from the vines and blossoms. I begin simplifying the background, using a Richeson no. 10, series 9050 brush to glaze (apply a transparent wash) with a mixture of Payne's Gray, Titanium White and Ultramarine Blue over large areas of background. This minimizes the contrast and helps unify the background with similar color and value.

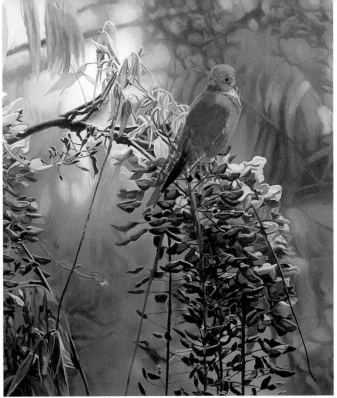

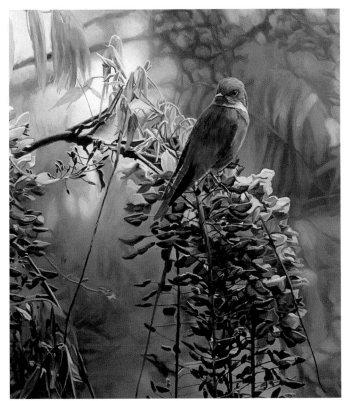

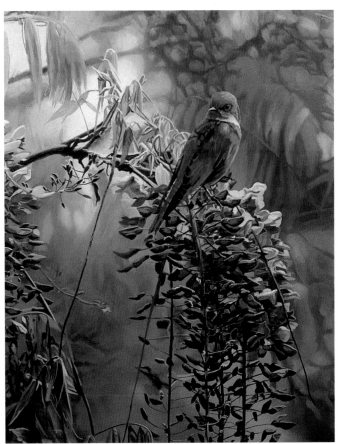

5 After the background of the painting is blocked in, it's time to put in the subject. I have a drawing of the bluebird on tracing paper, which I tape to the painting. Sliding white graphite paper underneath the drawing, I trace it onto the Masonite. Next, I begin painting the basic colors, which are Ultramarine Blue and Cobalt Blue for the blue areas on the head, wing and tail. For the chest, side areas and a bit

on the back, I use a combination of Burnt Sienna, Burnt Umber, Raw Sienna, and a little Titanium White. For the lighter white areas on the plumage I use quite a bit of Titanium White, along with a touch of the adjacent background colors. For the darker values on the bird I use Payne's Gray. I start very basic—just blocking in main colors, then adding detail on top.

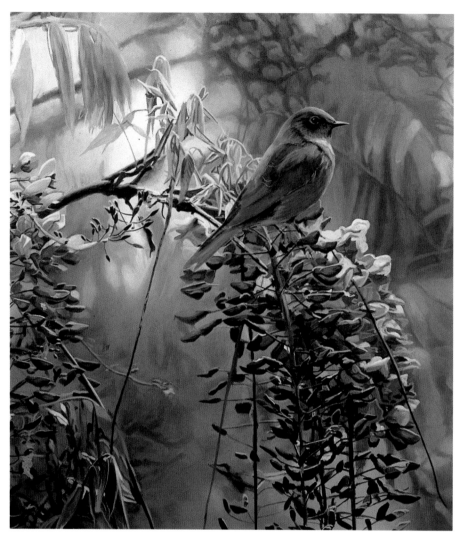

6 I like to live with a painting for a while; by now several weeks have gone by, and I've come to the conclusion that the pose is not looking right, regardless of the reference. The head turned back looks somewhat awkward. I choose a different pose from my reference photos (shown below) and draw a new bluebird, tracing it over top of the initial bird, painting out what extended beyond the outline and blocking in the new pose, just as I painted the initial bird. Using the same colors as in the first bird pose, I use primarily the Richeson no. 6, series 9050 flat brush. My brushstrokes follow the direction of the feathers, essentially following the contour of the bird, saving the detail for later. At this point I am simply painting in basic colors and shapes. I continue refining, adding detail, clarifying shapes and feather placement. I use transparent washes to unify areas, such as the wing area, the chest and the head. I'm also trying to keep a consistency in lighting on the bird to match the blossoms where the light is diffused, coming from the top right.

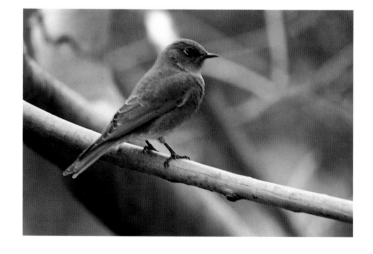

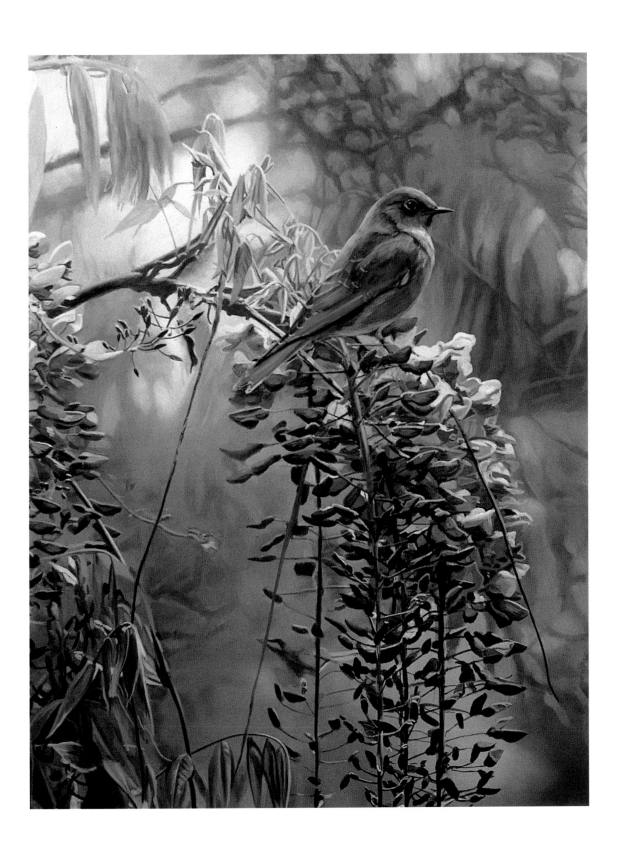

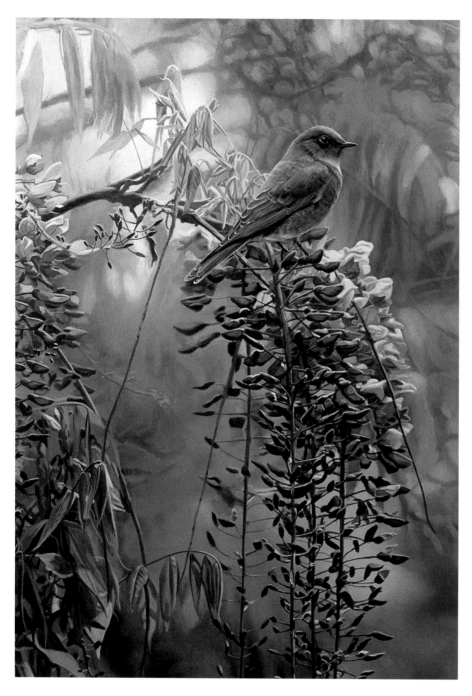

7 Now that the bird looks at home in the wisteria, I study the background to see what might detract from the subject. The bit of vegetation to the left of the bird seems too busy and has too much contrast. I use a larger brush, a Loew-Cornell no. 10, series 7500, and put a wash of Titanium White quite thinly over the whole area. This minimizes the contrast, making that area recede and creating a sense of atmosphere. Now I begin making the edges of foreground objects, such as the blossoms, sharper, while softening the edges of objects in the background. I scumble, using a dry-brush technique, scrubbing fairly quickly back and forth to create a blurred edge, sometimes actually pulling a bit of the background color on top of the object to make it recede.

I continue to study the background. It is still too busy, so I do a series of glazes with the wide flat brush, Titanium White and a touch of Payne's Gray to push the background farther back. I'm now painting a very transparent wash over large areas of the background to subdue contrast and color saturation. That way the nearer blossoms and bird will tend to pop forward, giving the painting a more three-dimensional look.

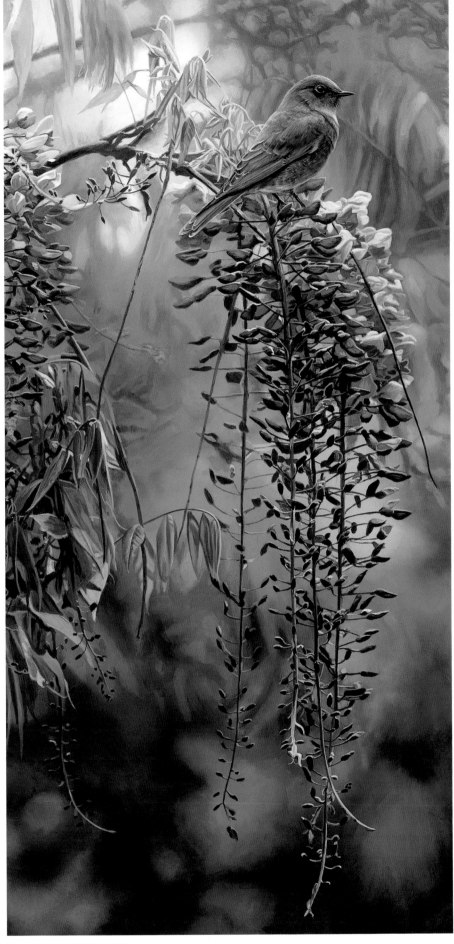

8 I go back and redefine areas of the blossoms that are a bit vague, putting in highlights on edges, showing more of their structure. I use touches of Cobalt Blue and Ultramarine Blue to help unify the blossoms and the blue of the bird. Also, I've put little touches of Dioxazine Purple on the head. For the blossom stems I use Burnt Sienna to redden them up and to help repeat the color of the bird's breast. At last the painting seems resolved and finished. I sign my name!

SPRINGTIME BLUES
28″ × 13¾″ (71.1cm × 34.9cm)

After the Storm

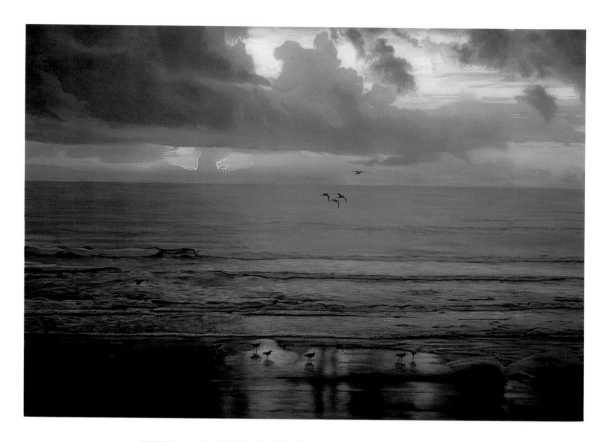

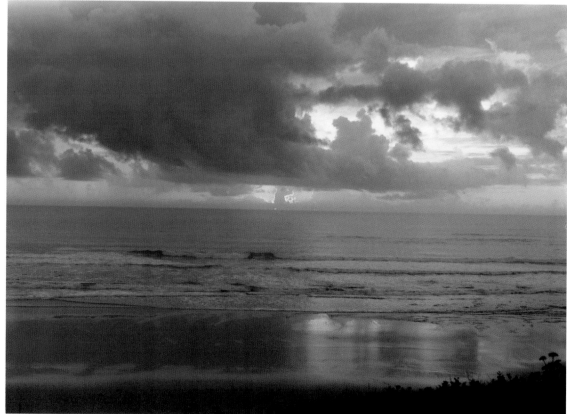

Reference Photos
After reviewing several photos of a dramatic seascape, I knew I had the genesis for a painting.

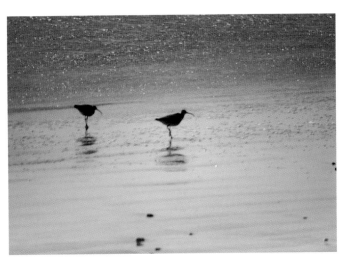

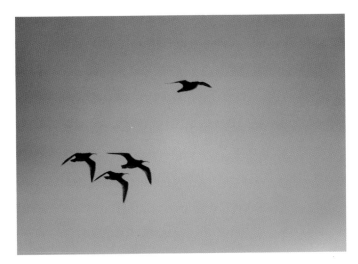

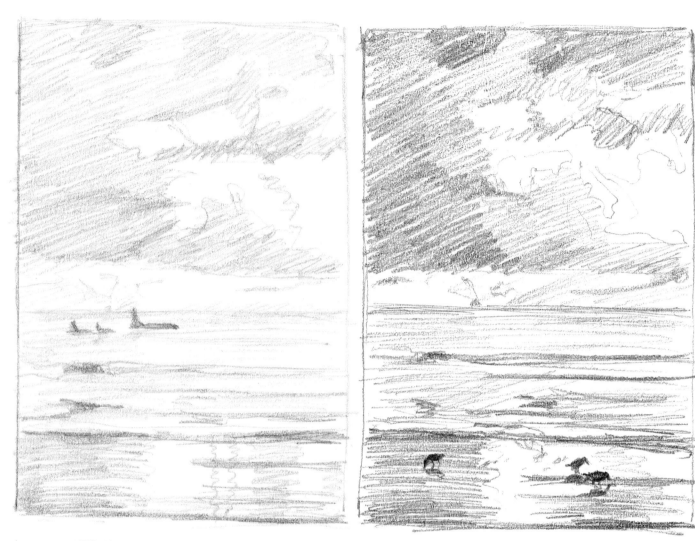

Thumbnail Sketches

First I drew some thumbnail sketches with orca whales, but decided instead to paint whimbrels (seabirds) in a horizontal format—the painting concept seemed dramatic enough without whales.

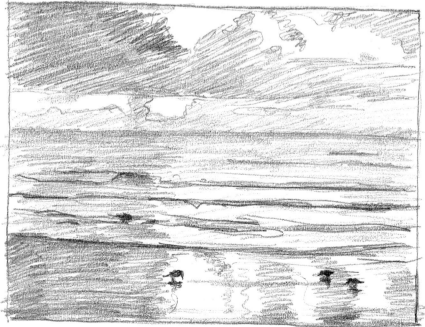

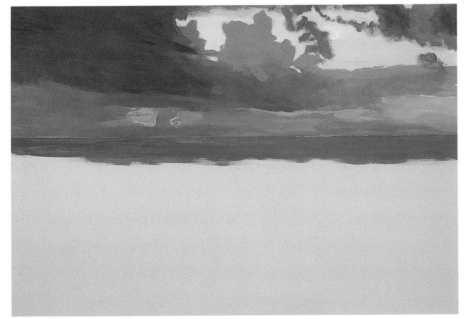

Supplies

- Untempered Masonite board
- White gesso
- Ruler
- Liquitex acrylic paint

 Turner's Yellow
 Unbleached Titanium White
 Titanium White
 Cadmium Orange
 Ultramarine Blue
 Burnt Sienna
 Dioxazine Purple
 Payne's Gray
 ACRA Violet (Quinacridone Violet)
 Yellow Medium Azo
 Light Magenta
 Light Portrait Pink
 Cerulean Blue
 Raw Sienna
 Raw Umber

- Loew-Cornell no. 10, series 7500 filbert brush
- Robert Simmons 1½-inch (38mm) white sable brush
- Richeson no. 4, series 9000 round brush
- Richeson no. 6 and no. 8, series 9050 flat brushes
- Richeson no. 2, series 9000 brush
- Low-tack tape
- Airbrush
- Gloss medium

1 First I make a basic drawing of the horizon line and larger cloud shapes. I use a ruler to make the horizon straight and truly horizontal. Then I begin blocking in basic colors, using Turner's Yellow, Unbleached Titanium White, Titanium White and Cadmium Orange, painting the lightest area of the sky first with a Loew-Cornell no. 10, series 7500 filbert brush. For the darker areas of cloud I use mixtures of Ultramarine Blue, Burnt Sienna, Dioxazine Purple, Payne's Gray, ACRA Violet (Quinacrilone Violet), Yellow Medium Azo, Light Magenta and Light Portrait Pink.

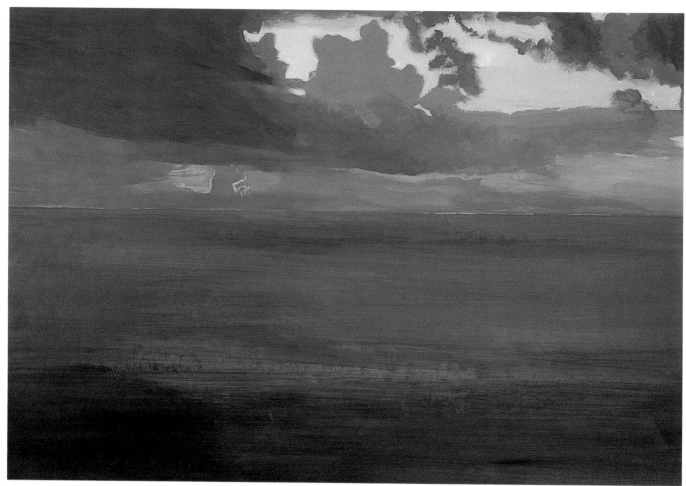

2 After the sky is roughed in, I use a Robert Simmons 1½-inch (38mm) white sable brush to block in the water area, using a mixture of Dioxazine Purple, Payne's Gray, Ultramarine Blue, Cadmium Orange, Titanium White, Light Magenta, ACRA Violet (Quinacrilone Violet) and Cerulean Blue. I use Burnt Sienna and Payne's Gray for the underpainting in the foreground wet sand area.

Break Your Painting Into Sections

I am essentially working on this painting in three sections: the sky, the middle horizontal area of the painting from the horizon down to the first wave, and the bottom third, which includes the wet sand and foreground waves. Breaking the painting down into sections is less overwhelming. By dividing the work areas I am better able to paint what I see.

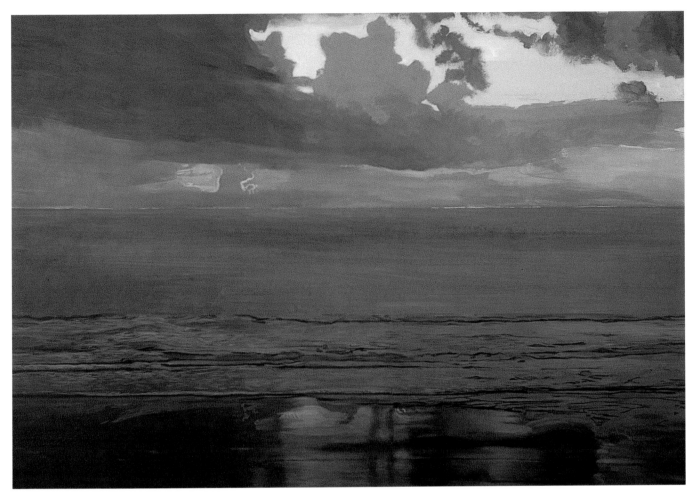

3 After the undercoat of the water area is blocked in, I start painting the foreground and light orange areas reflecting on the wet sand. The colors are Cadmium Orange, Burnt Sienna, ACRA Violet (Quinacrilone Violet) and Titanium White, with Turner's Yellow for the light that reflects on the sand. The dark areas of wet sand are a blend of Payne's Gray, Burnt Sienna and Ultramarine Blue. The foreground waves have the same colors as the sand, with the addition of Cerulean Blue and Titanium White for the foam on the waves.

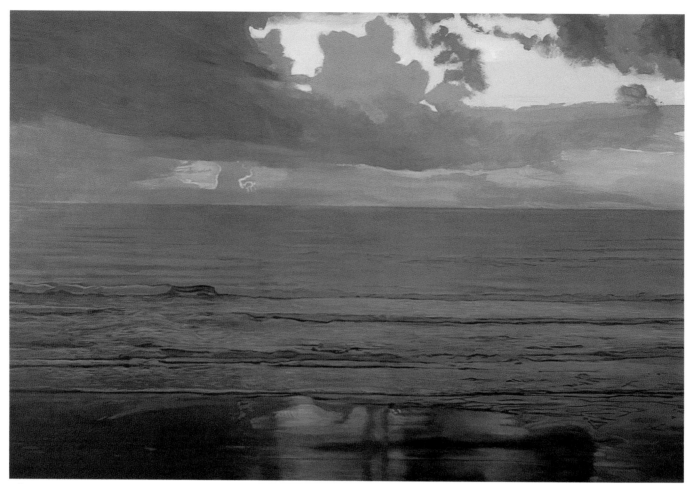

4 I paint more of the background waves with the Loew-Cornell no. 10, series 7500 filbert brush, using mixtures of Titanium White, Payne's Gray, Cadmium Orange, ACRA Violet (Quinacrilone Violet), Ultramarine Blue, Cerulean Blue and Burnt Sienna. I paint the base color first, then add the smaller waves and orange reflections on top, using the Richeson no. 4, series 9000 round and no. 6, series 9050 flat brushes.

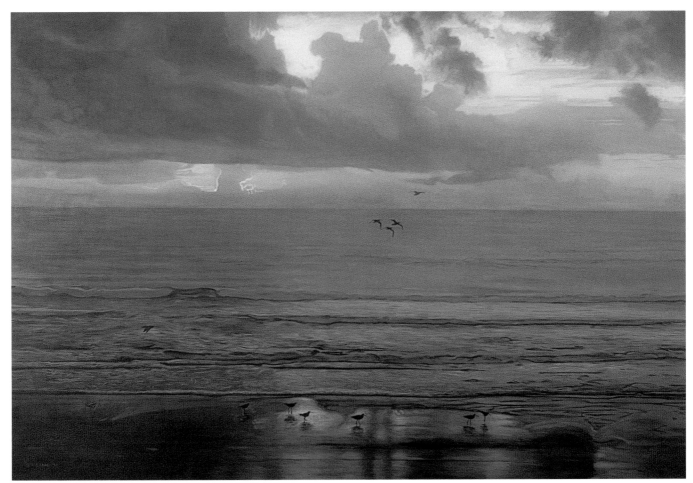

5 Now I begin to clarify shapes in the clouds, going for more particular color and value in those areas. The essential color combinations in the darker purplish areas are a combination of Payne's Gray, Ultramarine Blue with a bit of Light Magenta, Light Portrait Pink, and Dioxazine Purple with some Titanium White. In the more orange areas, closer to the horizon, I use combinations of Cadmium Orange, Turner's Yellow, Dioxazine Purple and Titanium White. After the clouds are blocked in, I glaze large areas with Light Portrait Pink, Raw Sienna and Titanium White. The paintbrushes I use for the sky are a combination of the Loew-Cornell no. 10 and Richeson no. 6 and no. 8, series 9050 flats. For some of the smaller detail—the light edging around the light area near the horizon—I use a smaller Richeson no. 2, series 9000 brush. I use a Loew-Cornell no. 10 brush to glaze over the entire sky area with a mixture of Titanium White and Raw Sienna, creating a warm golden wash that helps unify the various shapes and values.

In large areas of the sky that are lighter in value, I use a glaze of Titanium White and Unbleached Titanium White using a Lowe-Cornell no. 10, series 7500 filbert brush. In refining the sky I pay close attention to shapes, colors and values. I want to make the clouds look soft and fluffy with feathery edges. I use a combination of various techniques, from scumbling to dry-brush to wet-on-wet, blending one color into another. I also use a variety of brushes from the larger no.

10 to the smaller no. 6, even using a no. 4 round brush for some of the more linear shapes. To lighten up the sand area reflecting the sky a bit more, I use a combination of Cadmium Orange, Burnt Sienna, Titanium White and Turner's Yellow. This is done with the Richeson no. 4, series 9000 round brush. At this point I am also glazing large areas of sky and water with a single color to help unify and minimize the contrast, using the no. 10 flat brush. I use Titanium White and Unbleached Titanium White in the sky area and Payne's Gray in the darker area of the water, with Titanium White in the lighter side of the water on the right side of the painting.

Now that the painting is nearly complete, I paint the bird silhouettes with Payne's Gray and Raw Umber. Then I add backlighting with a mixture of Cadmium Orange, Unbleached Titanium White and Titanium White.

I airbrush the sky with the same colors I used initially, in order to soften brushstrokes and create a better sense of atmosphere. I have refined the waves in the foreground by adding detail, sharpening certain edges and softening others, and eliminating any transparent rough-looking areas that need more refinement and resolution. As a final step, I look closely at the birds to see if I can further refine the shapes of the bills and bodies. I am seldom completely satisfied—I believe this is a plus for the serious painter.

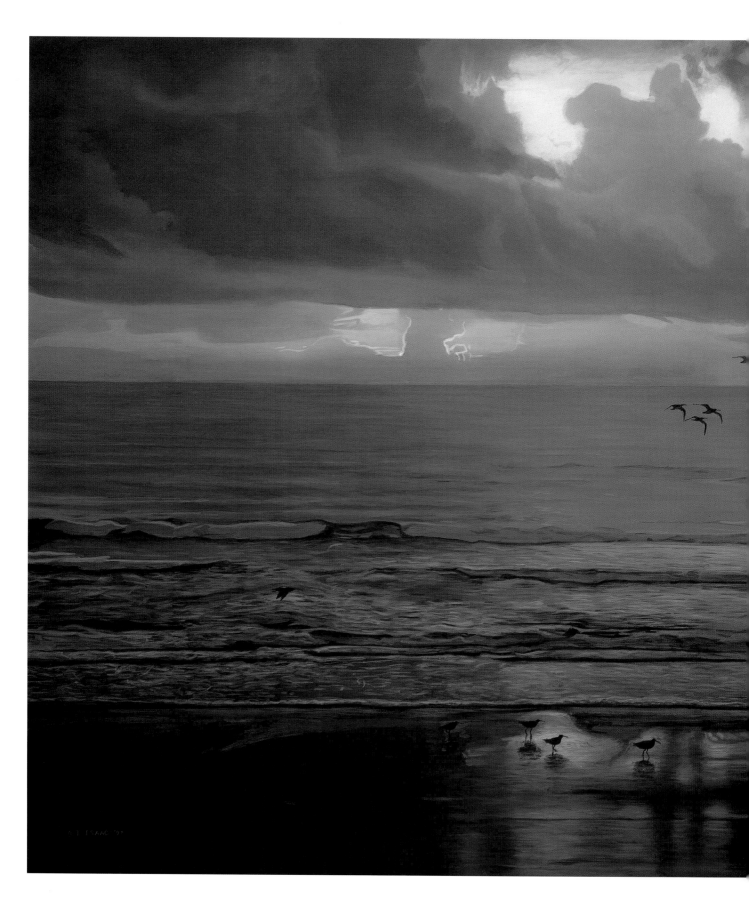

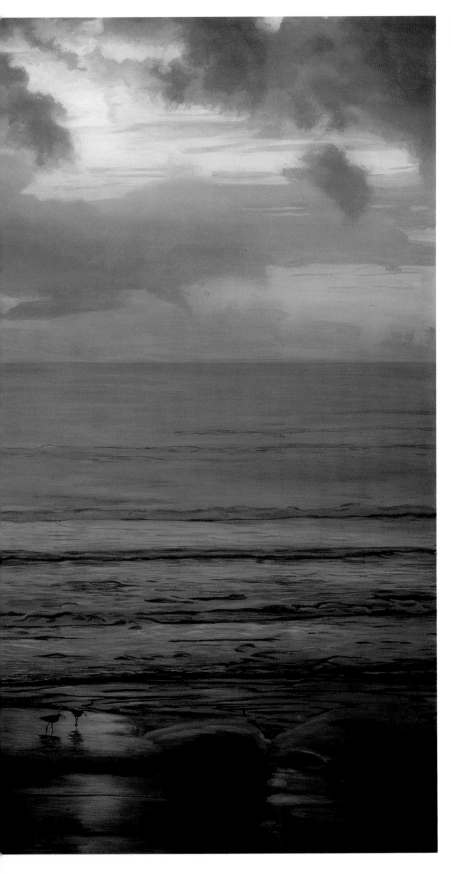

AFTER THE STORM
18″×26½″ (45.7cm×67.3cm)

Tyger! Tyger!

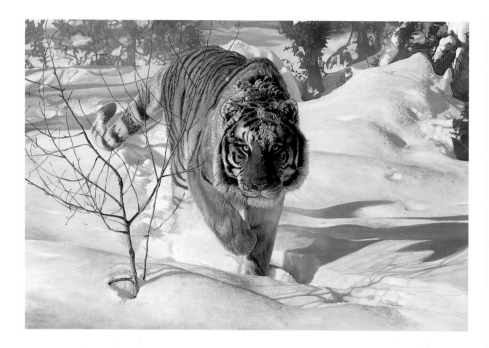

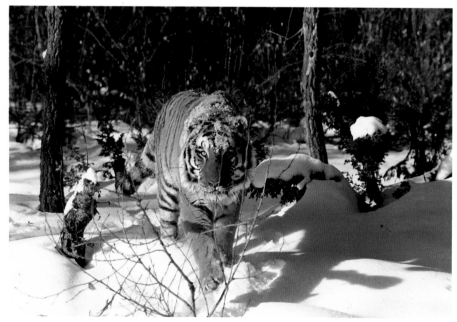

Supplies

- Untempered Masonite board
- White gesso
- Liquitex acrylic paint

 Payne's Gray
 Raw Umber
 Cadmium Orange
 Turner's Yellow
 Burnt Umber
 Raw Sienna
 Burnt Sienna
 Titanium White
 Unbleached Titanium White
 Ultramarine Blue
 Chromium Oxide Green
 Cerulean Blue
 Light Portrait Pink

- Richeson no. 6, series 9050 brush
- Loew-Cornell no. 10, series 7500 brush
- Richeson no. 2/0, series 9000 brush
- Richeson no. 4, series 9000 brush
- Toothbrush
- Sponge
- Stiff brush
- Clear acetate
- Low-tack tape
- Airbrush
- Gloss medium

Reference Photo

After reviewing several photographs of tigers that I had taken, this particular reference spoke to me the most. I liked the eye contact with the viewer and the implied motion of the cat coming right at you. In animals, body pose, tail placement and position of ears all help convey attitude.

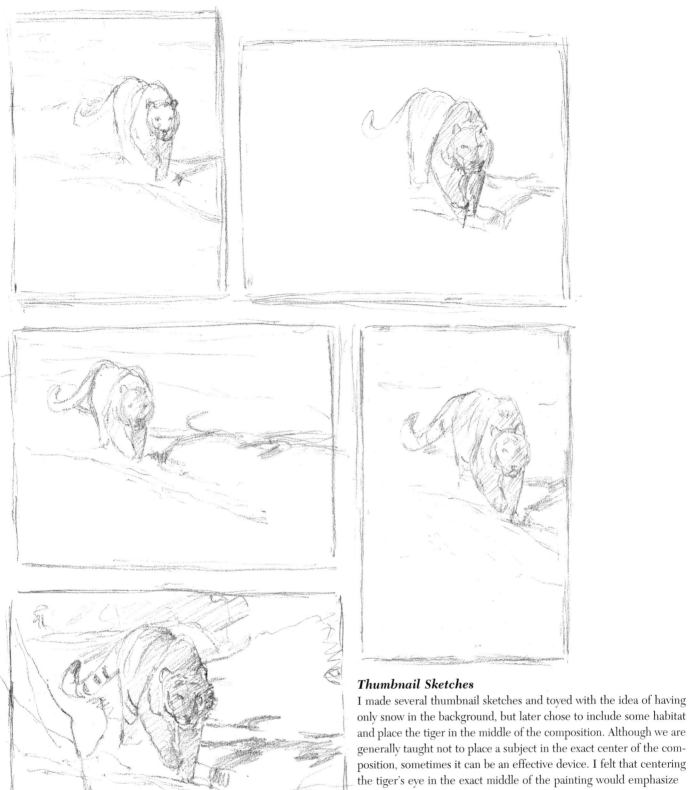

Thumbnail Sketches

I made several thumbnail sketches and toyed with the idea of having only snow in the background, but later chose to include some habitat and place the tiger in the middle of the composition. Although we are generally taught not to place a subject in the exact center of the composition, sometimes it can be an effective device. I felt that centering the tiger's eye in the exact middle of the painting would emphasize its importance and add to the impact of the painting. Also adding to the impact of this painting concept is the use of complementary colors: the orange of the cat and the blues of the shadows on the snow. Complementary colors seem to vibrate next to each other. This will push the cat out to the viewer.

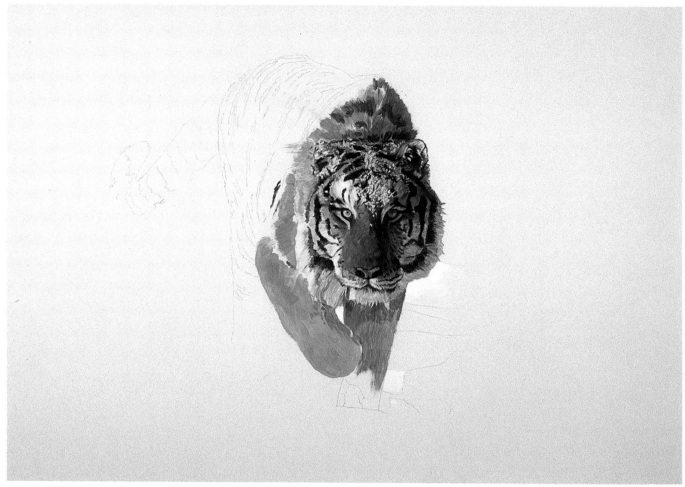

1 After I finalize my design, I draw the tiger on the primed board (primed with diluted gesso, Payne's Gray and Raw Umber). Normally I paint the background first and then paint the subject on top; in this case I decide to start with the tiger since it is such a dominant part of the design. After the drawing is on the board, I begin blocking in the face of the cat. The brush I use is the Richeson no. 6, series 9050. The paint colors for the essentially orange fur are Cadmium Orange, Turner's Yellow, Burnt Umber, Raw Sienna, Burnt Sienna, Titanium White, Unbleached Titanium White and Payne's Gray. For the snow on the tiger's fur I use Titanium White, Payne's Gray and Ultramarine Blue. I use the same colors for the white fur. The dark stripes are basically Payne's Gray and Burnt Umber. The light color in the eye is a mix of Titanium White, Payne's Gray, Turner's Yellow and some Raw Sienna. I also add a bluish reflective light on the bottom of the eye that is in shadow—bounce light from the sunlit snow.

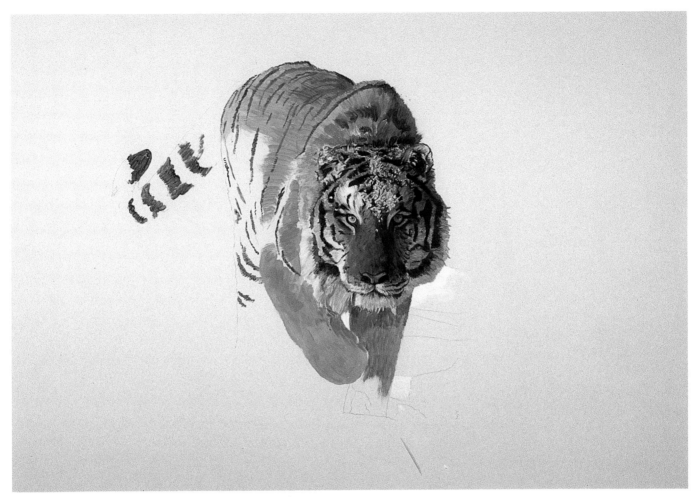

2 Continuing to block in the body with the colors from the previous step, I apply my brushstrokes in the direction the fur grows. My paint is fairly transparent at this stage. I paint the black stripes on the body and tail using Payne's Gray and Burnt Umber.

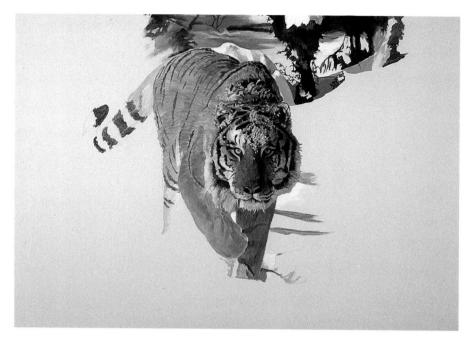

3 I continue to fill in the rest of the fur, using the same color combination that I used on the face. I am aware that the black stripes on the body, tail and leg will follow the contour of the anatomy. At this stage I begin blocking in the background snow and vegetation. I use a combination of Payne's Gray, Burnt Umber, Chromium Oxide Green and some Raw Sienna for the vegetation. The snow is a mix of Payne's Gray, Titanium White, Cerulean Blue, Ultramarine Blue and Light Portrait Pink. I use the Richeson no. 6, series 9050 and the Loew-Cornell no. 10, series 7500 brushes.

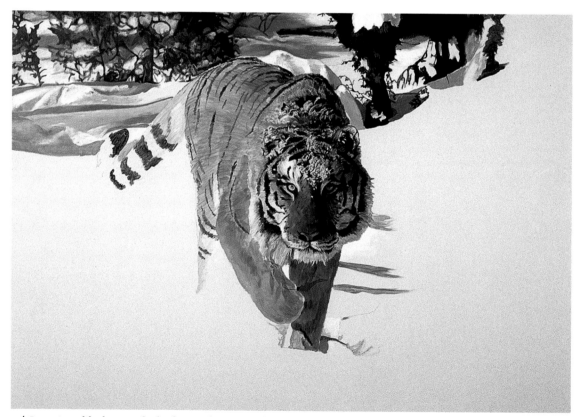

4 I continue blocking in the background, painting the dark vegetation and the light and shadow on the snow. I'm painting the background darker than it actually should be, because I know I will use my airbrush to mist it back in the stages to come. I want to paint the background before I finish the tiger, because I want the edges of the fur to overlap the completed background.

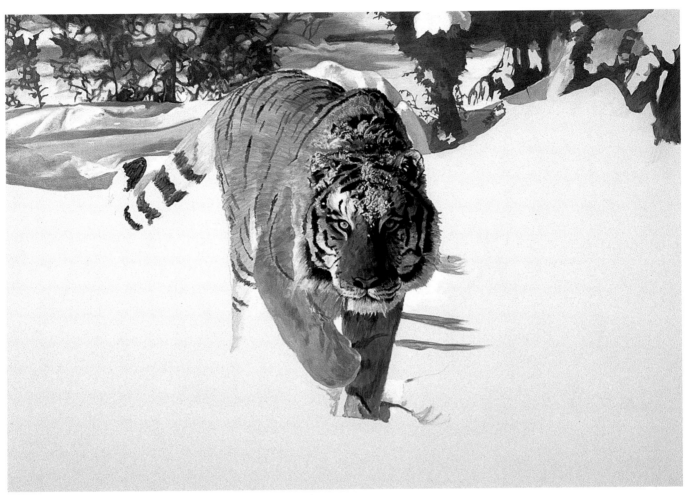

5 Here I have completed blocking in the basic lights and darks in the background. Later I will add detail, texture and atmosphere.

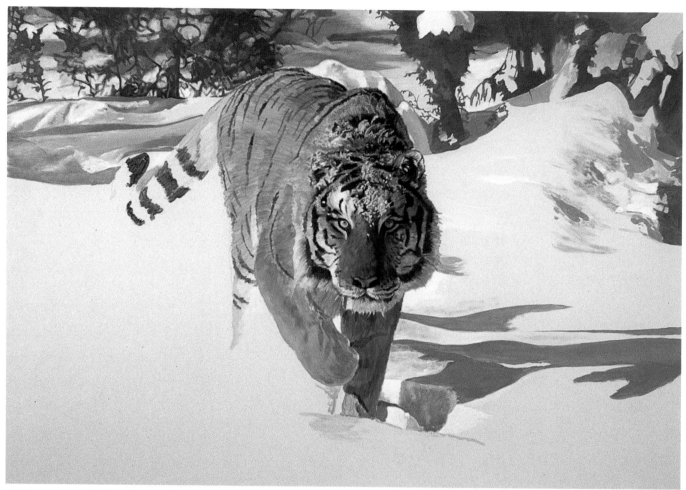

6 I continue to block in the rest of the tiger's shadow and the texture on the snow in the upper right corner. I will use my original toned gesso for some of the color in the snow. The bluish shadows are painted with the Richeson no. 6 and the Loew-Cornell no. 10 brushes. The colors used are Payne's Gray, Ultramarine Blue, Cerulean Blue, Light Portrait Pink and Titanium White.

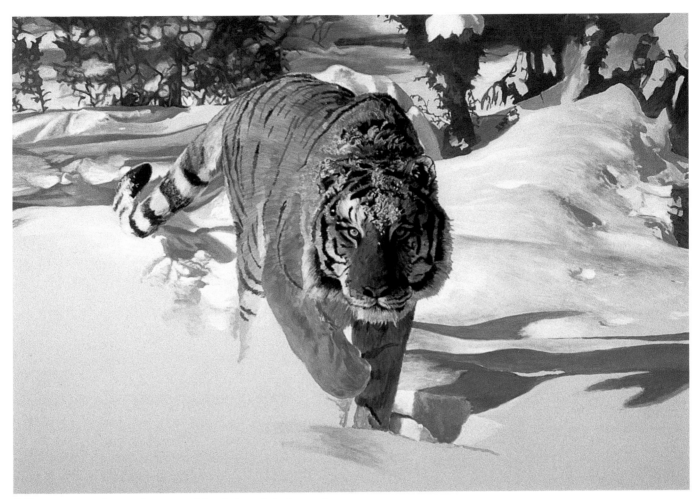

7 I continue working in the snow, adding light and shadow to show form. In the shadow near the tiger's standing front leg I add some of the warm colors I used in the fur, because snow is a color-reflective surface. I also put cool colors on the tiger's fur from the bounce light and bluish color reflected from the snow.

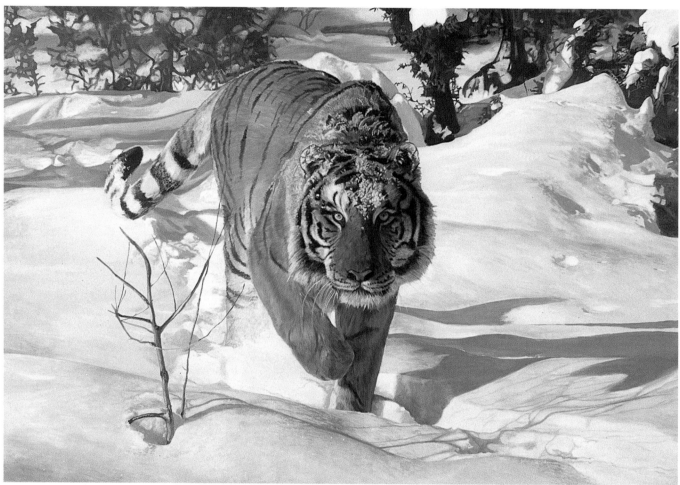

8 At this stage I work primarily on the tiger, particularly his raised foreleg, adding light, shadow and detail. I also complete blocking in the snow. To create some of the texture in the foreground snow, I use a toothbrush to splatter, a sponge, and I stipple with a stiff dry brush, all with Titanium White. These techniques create the granular texture of the snow. I begin to add foreground branches using Payne's Gray, Burnt Sienna, Burnt Umber, Titanium White, Raw Sienna and Ultramarine Blue. For the smaller branches and detail in the snow and fur, I use the Richeson no.⅔ and no. 4, series 9000 brushes.

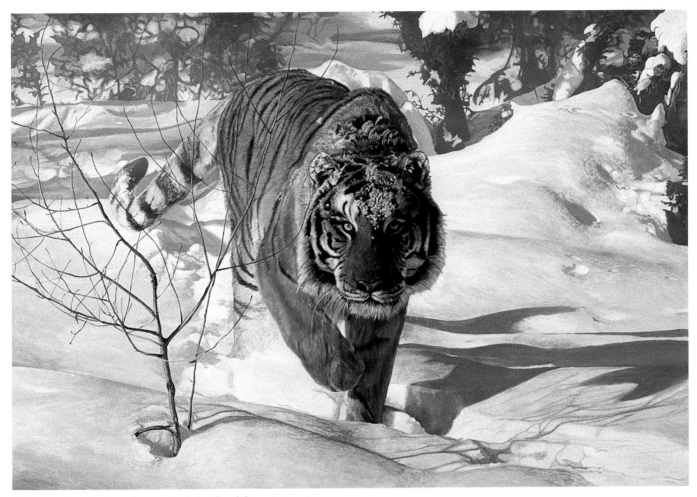

9 I complete the branches on the left side of the painting. I use an airbrush with Titanium White to subdue the background in order to enhance a feeling of depth and add atmosphere.

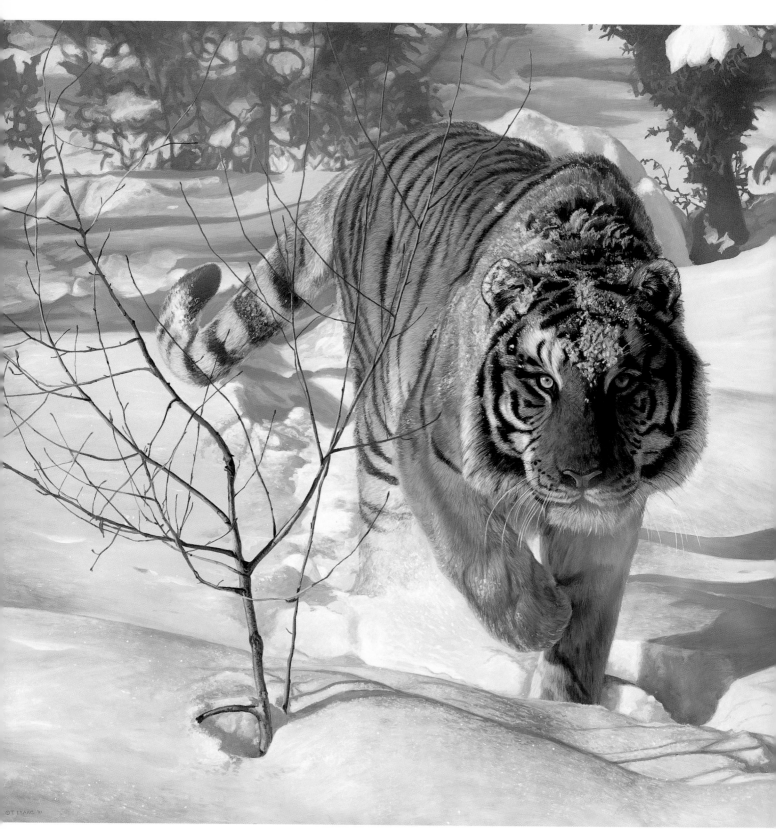

TYGER! TYGER!
28" × 40" (71.1cm × 101.6cm)

10 In the final stage I airbrush breath using Titanium White. I also use the Richeson no. 4, series 9000 brush and paint bits of snow on the tiger's raised front leg with Titanium White, first using a piece of clear acetate over the top of the painting to experiment with the location of the snow bits. I continue to add detail and texture to the foreground snow and to the tiger and, finally, sign the painting.

Creating Your Best Painting

You have put much thought into your painting and how to put it together. Now that you've completed your painting, you should ask yourself these questions, which are a checklist to help you create your best painting.

✓ Does my painting have a magical setting? Is it a good concept?

✓ Am I showing a good pose and attitude of the animal or bird? Does the subject have dignity?

✓ Is the anatomy correct? How is the GISS (a birder's term for general impression, size and shape)?

✓ Does my painting have interesting lighting and atmosphere? Does it convey a mood?

✓ Have I created a successful illusion of depth in the picture plane or field?

✓ Does my piece have interesting color? Have I used the design properties of color well?

✓ Are there interesting shapes? Is there a good breakup of space? Do abstract shapes lead the viewer's eye where I want it to go?

✓ Is there a sense of action implied, impending or actual? Does the painting tell a good story?

✓ Have I captured a special moment?

✓ Is there a unification of the subject and setting?

✓ Does the painting have a nice light and dark pattern? How would it work in black-and-white or out of focus?

✓ Is my reference material good? (Garbage in, garbage out.)

✓ Does it look like I am seeing it for the first time? Is the concept fresh?

✓ Is the animal or bird depicted in correct scale to the background or habitat?

✓ Have I created something that elicits an emotional response?

HSING-HSING (BRIGHT STAR)
12" × 9" (30.5cm × 22.9cm)

©T.ISAAC '96

Professional Concerns

After you have created a body of work, it is time to think about how to market it. You need to consider several things along the way.

PHOTOGRAPHING YOUR WORK

Take a slide or transparency of each piece. Label the slide or transparency with the appropriate dimensions, medium, date of completion, and your name and address. It's a good idea to make duplicate slides to submit to various shows and publications.

FRAMING

Framing should complement the art, not distract from it. Craftsmanship is important not only when creating art, but also with the framing and presentation of that art. Framing can be expensive, so don't feel you must frame everything. Some paintings should be chalked up to experience, without trying to sell them.

GALLERIES AND GROUP SHOWS

When you are at a point with your work that you are ready to approach galleries, it's important to do some homework first. Check out many galleries and ask artist friends what places they would recommend. Begin with local galleries. That way you can keep tabs on the work and check with the gallery about the response to it. Make an appointment first and have a professional portfolio of quality slides, resume and perhaps a framed original to show.

There are some important points to keep in mind when having your work in a gallery. Ask for a contract that puts the consignment commission breakdown in writing. If the gallery doesn't have one, create your own. How long will they want to consign the art? You will also want to know how long it will take to get payment upon the sale of the original. You should also ask the gallery if the work is insured while in their possession. Pick a gallery that is reputable and includes work similar in flavor to your work.

Once you have success at the local level, you may want to approach galleries nationally. To learn about galleries around the country, subscribe to all the periodicals you can afford that feature wildlife art, or frequent your local library to see if they might carry these periodicals. Studying the magazines will show which galleries advertise, which have shows that might feature wildlife art and which represent artists whose work might be similar to yours. Sending a packet of resume and transparencies, photos or slides to these galleries is a good way to initiate contact. Don't forget to include a self-addressed, stamped envelope for the return of your materials.

Getting involved with group shows at galleries or at "booth shows" is a good way to broaden your network. Local art festivals are another way to get started. At these shows where you staff your own booth and sell your own art, the feedback from the public can be quite helpful. It is also helpful to meet other artists and exchange ideas that deal with the art profession.

Many artists prefer to sell their own work and bypass the galleries. I prefer to have galleries handle the sales of my work, because this allows me more time to do fieldwork and to work on my art.

PRICING

Pricing your work will be a continual struggle. When first starting out, keep the prices low. You can always increase them as you grow in stature as an artist. The gallery you work with can give you suggestions and feedback on appropriate pricing. Keep good records of all sales and expenses for business and tax purposes.

SHIPPING

When you conquer the hurdle of the initial contact and the gallery decides to try your work, the next step is to ship the framed piece to the gallery. Most galleries make artists responsible for paying inbound shipping, and they in turn are responsible for return shipping if the piece does not sell. When shipping art, it is important to crate it properly with adequate packing material. I use wooden crates with foam rubber packing material. I also suggest insuring the work, just to be on the safe side. Some shipping companies will insure the work for the wholesale value; some have a set maximum insurance value for fine art. Check around first. Or purchase a business insurance policy to cover shipping, among other things.

PUBLISHING

Once you have success with original sales and it becomes hard to keep up with the demand for your work, you may want to consider approaching a publishing company to produce limited-edition reproduction prints from your originals.

I have taught several workshops where some of the students are interested in being published when they have produced only a few paintings. It is better to concentrate on perfecting your craft than rush to be published or to self-publish. Many artists publish their own work at great expense only to find that they sell a few prints to family and friends. However, if your work truly warrants being published, it can be a wonderful thing. A good publisher gets both your name and images out to the public. My reputation as an artist has greatly improved since I have been published. It is important to have everything written in contract form if you have a publisher or licensing agent interested in your artwork. Keep the lines of communication open with all the people who may be involved with the selling and promoting of your work.

RESOURCES

Professional concerns are well addressed in books written on the subject. They are available in new and used bookstores, and in libraries. These books address legal and marketing issues, have sample contracts and can be enlightening. I have several in my own library. Another resource is workshops and seminars that address these concerns. Contact your state and local art organizations and institutions of higher education.

Gallery

SHORE PATROL—RED FOX
13"×36" (33cm×91.4cm)

LIGHT AND MIST—TRUMPETER SWANS
20″×40″ (50.8cm×101.6cm)

IN THE ELM
8¼″×23⅞″ (21cm×60.6cm)

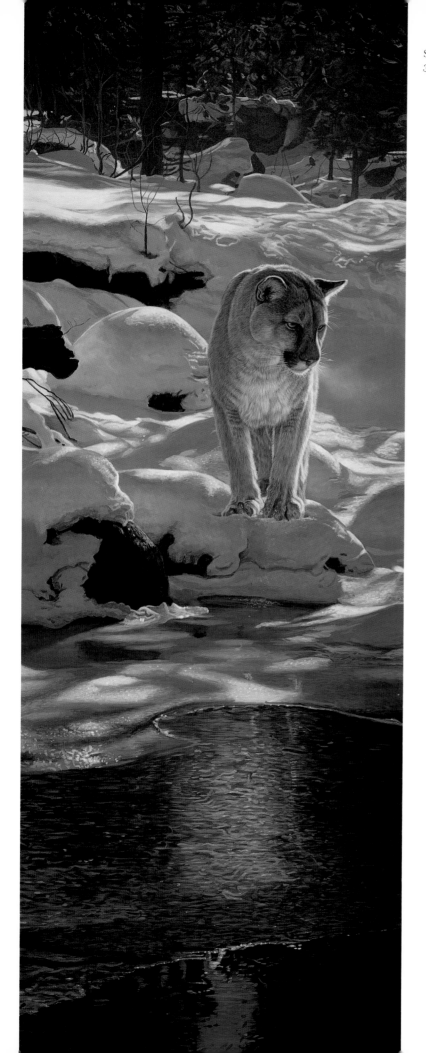

SNOW SHADOWS—COUGAR
36½″ × 13½″ (92.7cm × 34.3cm)

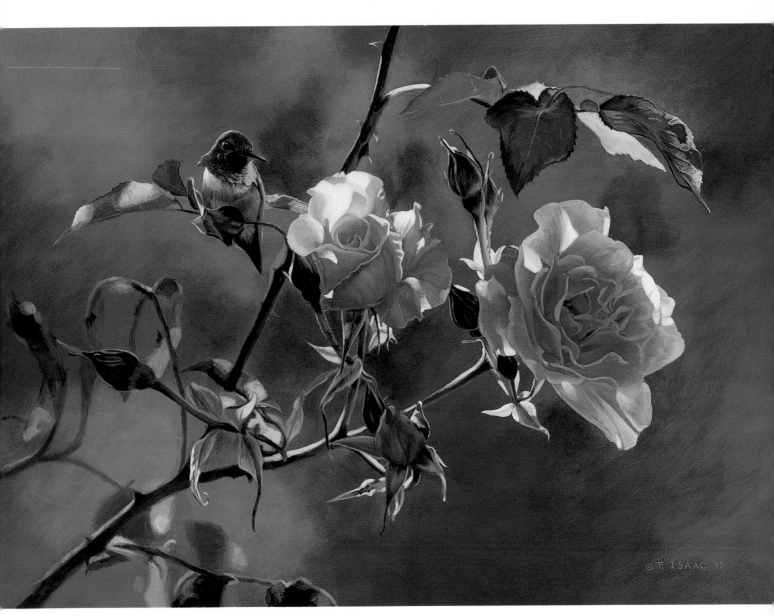

SHADES OF SUMMER
9½″ × 13½″ (24.1cm × 34.3cm)

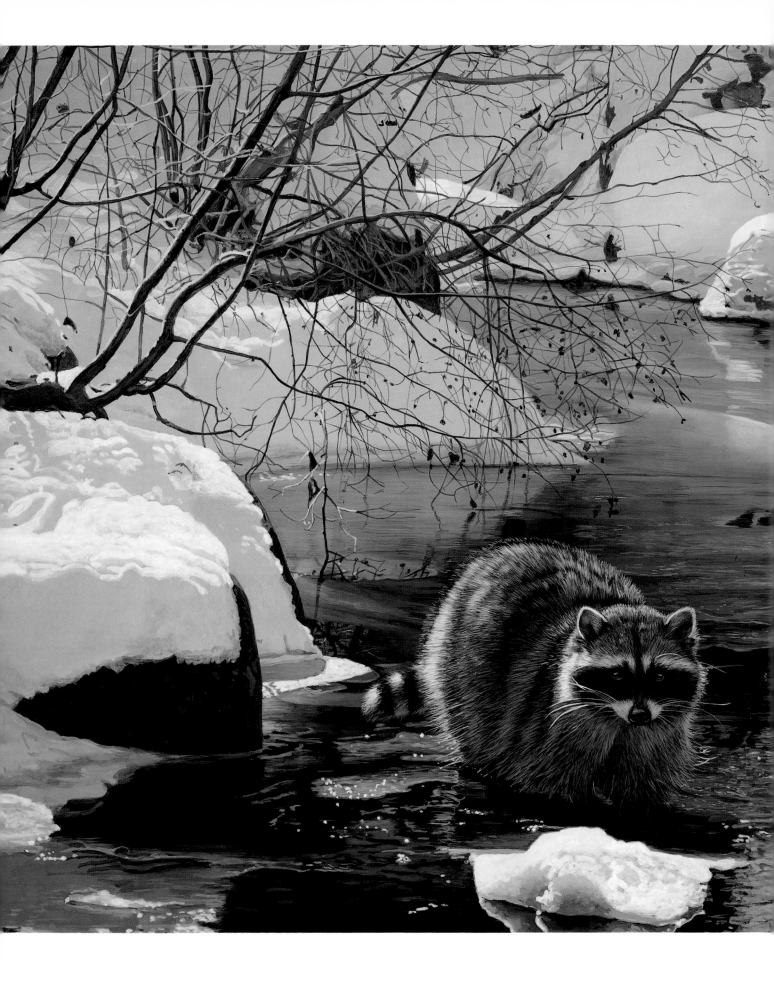

COOL PAUSE
16″×24″ (40.6cm×61cm)

Conclusion

I cannot think of a better profession or life than being an artist. I love both art and nature, and to be an artist who paints wildlife combines nearly all of my interests. My career is much more my life than a job. By far the most exciting aspect is doing fieldwork and observing nature firsthand. This does not have to be on an exotic trip to Africa. It can mean taking a walk at a local park or observing bird feeders in your own yard. But remember, when photographing animals and birds in the wild, wherever you are, it is important to respect their space. If your actions alter their behavior, you are too close.

The key to being a good artist is learning to see. Go to as many galleries and art museums as possible. The more you see, the more you will be enriched. Take painting workshops and a variety of courses that will broaden your knowledge of art and nature. The way to get better is to make mistakes and, as the slogan says, "Just do it." Don't wait to be inspired before you start painting. Simply begin and the inspiration will follow.

If you have the luxury of time to hold on to a painting, it is nice to live with it a while before you send it out of your studio. Often I see more to do on a painting after I take a little break from it. It is also great to have a spouse, friend or fellow artist who has the knowledge and patience to critique your work. It is important to have more ideas than time to paint them. That way you can be selective about your ideas and, hopefully, paint your strongest ones. Keep in mind that there is no absolute right way of painting—all artists paint with slightly different techniques and approaches. Don't try to push a style. With time and experience a style will find you.

Good luck and happy painting!

MIDSUMMER DREAM—HUMMINGBIRD
24" × 16" (61cm × 40.6cm)

©T ISAAC '97